DERBYSHIRE
MURDERS

DERBYSHIRE MURDERS

MICHAEL POSNER

AMBERLEY

First published 2012

Amberley Publishing
The Hill, Stroud
Gloucestershire, GL5 4EP

www.amberleybooks.com

British Library Cataloguing in Publication Data.
A catalogue record for this book is available from the British Library.

ISBN 978 1 84868 151 4

Typesetting and Origination by Amberley Publishing.
Printed in Great Britain.

CONTENTS

INTRODUCTION

Hang 'em high and give them a one-way ticket to eternity. That seemed to be the answer to all the criminal ills that kept hangmen fully employed, yet it still did not stop the villains from breaking the law.

From sheep and horse stealing to theft, robbery, rape and murder, the sentence was all the same – capital punishment. The risk was great but those intent on breaking the law did not seem to give much thought to the bleak outlook if they were caught. Some had to steal to keep their families alive, but others did so because that is what they were good at.

The sentences were cruel. Apart from hanging, there were other offenders who faced transportation for seven years and up to life with little or no chance of ever getting back home, because most of them would have no money for a return journey.

People were hung, drawn and quartered, whipped, burned at the stake or even pressed to death, with ever-increasing weights placed on their bodies until they confessed or suffocated. There were other indignities imposed upon those sentenced to death. They would either be handed over to a surgeon for dissection – sometimes in public – or they would be gibbeted as a lesson to others.

Fertile human minds have amazing abilities, and gibbeting had to be high on the list. Shortly before a particularly nasty murderer was due to hang, he would receive a visit from the local blacksmith who would measure him for a steel frame 'suit'.

Once he was executed and then cut down, he would be encased in the frame and covered with tar, then hung from a tree until the birds had picked his carcass dry. It remained there as a lesson to the local population.

There was no such social nicety in those days as 'human rights' that could be abused. Human rights were two or three hundred years down the line. Cruelty was part of everyday life. People accepted it and got on with what they had to because they knew what to expect if they crossed the line.

And people complain today of the sentences they receive if they break the law! Maybe the stocks should be brought back and set up in the local market squares so that a lesson could be made of thugs who carry out violence for the sake of violence.

The 'cat o' nine tails' could also be reintroduced, but that might be a breach of human rights...

Laws are created to keep people in society under control. Break them and suffer the inevitable. Don't whinge or complain; think about prisoners in the United States, where a life sentence in jail means just that.

Those who think a judge might have been too tough on them should read the stories in this book, and then decide whether they should complain...

Michael Posner
Bristol, 2012

1

DEATH OF A GIRL ON
A SUMMER'S DAY

Alfred Gough was in a blind panic. He had killed a little girl and was wandering around Brimington, in Derbyshire, with her body stuffed inside his handcart, not knowing what to do.

A short time earlier, he had lured the six-year-old into tall grass at the side of a narrow farm lane, where he sexually abused and throttled her to death.

The thirty-four-year-old, described by those who knew him as a man of 'repulsive appearance', was an itinerant who visited villages and hamlets in the county collecting rags and handing out to children paper flags and small toys in exchange.

Like many child molesters, Gough relished the cruel misery he piled on the victim, but once the abuse and lust were complete the child had to die. It was a simple as that. Usually what had happened was creation of 'the little secret' between abuser and abused. But could the child be relied upon to keep quiet? It was too big a risk for Gough to take. His problems multiplied rapidly and to let the youngster live meant he could soon be identified. To make sure the secret remained exclusively theirs, there was only one answer; she had to be killed, which created another, far more serious problem. Get caught and convicted of murder and the hangman was a date in his diary.

On 26 August 1881, pretty little Eleanor Windle was playing with her friends on a warm summer's day not too far from her house at Brimington near Chesterfield. It was a Saturday and there was no worry about school. The sky was a clear blue and a slight breeze blew up little puffballs of dust inches above the road. Tall grass and wheat, ready to be harvested, bent and swayed slightly, and the squeals and laughter of happy youngsters brought smiles to the faces of women as they carried out their daily tasks.

In the distance appeared the figure of Alfred Gough, pushing his handcart. The children saw, but all except young Eleanor ignored him as he drew closer. Gough did not intend to kill anyone that day or on any other, but when he saw the girls

something stirred inside him, a fearful feeling and one that he could not overcome until...

Eleanor ran and skipped towards Gough's wooden, rickety handcart, anxious to get a flag or a toy. The feeling Gough experienced was now overpowering and slowly the two of them walked towards a lane, the little girl looking up at him chattering happily.

By the time they reached Johnson Lane, the pair had been seen by Harriett Johnson, an elderly spinster who lived in a house at the top of the lane. She later told a police superintendent that what she saw disgusted her; Gough was indecently exposing himself to the little girl. In the hope that she might stop Gough, Miss Johnson went to get a broom handle to defend herself then planned to attack him. But by the time she returned, Gough and Eleanor Windle had disappeared. That was the last time she was ever seen alive.

Gough stayed in the village for a while, pushing his handcart along, before he decided it would be best to get away from what he had done. As the afternoon began to shorten into the evening Eleanor's father started looking for his daughter and asked Gough whether he had seen her. The hawker, anxious to leave, claimed he had seen a little girl answering her father's description earlier in the day near the local cemetery.

Night began to fall and still there was no sign of Eleanor Windle. Her father was, by now, seriously worried and agitated about the safety of his daughter. Groups of men started to search for the youngster but as the blackness of night hampered their searching they called off the hunt until the following morning.

By eleven o'clock the following morning there was still no sign of Eleanor. Search parties were again organised. At about the same time, toll-gate keeper, Charles Brown, decided to make a search of his own to check on something from the day Eleanor disappeared. He took off to a small semi-private road leading from the village of Stavely to Barrow Hill, where late the day before he had seen Alfred Gough and his wooden cart.

Now nearby was an area called Hoole's Plantation. Mr Brown suddenly noticed some wheel marks that he had never seen before and decided to investigate the plantation. As he carefully searched through the grass and weeds he came across a small bag made of coarse canvas, which he remembered was something he had seen being carried by the missing girl. He moved slowly and carefully further into the plantation then suddenly saw the body of the little girl lying on her back under a small tree 'dead, quite cold and stiff'.

He later told the police superintendent in charge of the investigation that a piece of canvas was tied around her neck and it was evident that the child had died of suffocation. A local reporter from the *Derbyshire Times* reported that when Mr and Mrs Windle were told of their daughter's death, 'The agony and distress ... on discovering that their daughter had been foully outraged and then murdered, may be far more easily imagined than described.'

Gough did not run off to hide because that would have created suspicion. Instead he headed for home territory in Chesterfield where he would be among people he

knew and mistakenly believed he would find safety. Superintendent Carline from the Chesterfield division of Derbyshire County Police was put in charge of the case and eventually, after not too much searching, he found the wanted man at the town's Buck Inn in Holywell Street.

The policeman told Gough he had come to arrest him for the murder of Eleanor Windle and, in spite of a forceful denial, he was handcuffed and taken to the county police station at nearby Marsden Street.

The following day, Monday, he was taken before Mr A. Barnes MP, a local justice of the peace. The magistrate was told that Gough was seen at Johnson Lane in the company of the dead girl and of the indecent behaviour witnessed by the elderly Miss Harriett Johnson. He was remanded in custody for a week.

By now people had heard of the murder and that someone had been arrested. As Gough was being taken back to the police station he was greeted by a crowd of heckling people. The *Derbyshire Times* covered his appearance before the local magistrates and reported, 'Amidst the execrations and hootings of a large crowd that had collected outside the offices, the prisoner, who appeared to be totally indifferent in regard to the serious position in which he stood, was taken back to the police station.'

The next step in the rapid judicial process was Gough's appearance before an inquest jury, where the evidence against the street hawker was presented, 'with the most amplitude of detail by a multitude of small facts and by many witnesses each speaking to perhaps a minute part of the chain'.

The ability of journalists in those days to skilfully use the language in which they specialised, is something to be highly admired, and I often wonder how they spared the time to express themselves in such a pleasurable way.

The jury found Gough guilty of murder and he was committed by the coroner to stand his trial at Leicester winter assizes in the middle of November.

The trial was, like all trials in those days, carried out with such rapidity that it was over within hours. Fairness is all things to all people and whether his trial was unbiased, unprejudiced and impartial could only be judged by the standard each person sets.

Mr Justice Mathew, resplendent in his red gown with ermine around the cuffs and down the front, sat severely in his seat while his clerk carefully placed on his head the dreaded black cap. The judge looked at Gough in the dock in front of him and declared:

You must be prepared to die. I cannot hold out any hope of mercy here. You yielded to one terrible, to one diabolical temptation, do not yield to another. Do not harden your heart but look for mercy where mercy alone can be extended to you.

I now proceed to pass upon you the sentence of the law, which is that you be taken from hence to the place from whence you came, and from then to the place of execution, that you be there hung by the neck until you shall be dead and that your body be buried within the precincts of the prison in which you shall have been last confined before your conviction.

The eyes of everyone in the courtroom turned towards Gough as he listened to the judge, but he received his sentence with that 'apparent indifference and unconcern which has distinguished his behaviour from first to last'.

He was escorted out of the dock by warders towards the horse-drawn tumbrel cart to be returned to Derby prison and confinement in the condemned cell. His execution behind the prison walls was fixed for eight o'clock on Monday morning, 21 November 1881.

It was an unusually long time – close to three months – between the day of sentence and the execution. Normally the courts did not like to waste time hanging felons and set a date within three or four days. Maybe the judges did not want a condemned person to have too long to think about what was coming.

Gough was kept occupied while he waited for his life to come to an end. He spent a lot of time writing to his brother and sister, as he no doubt tried to come to terms with what he had done. Many letters passed between him and his siblings even before his trial started but at no time did he ever indicate his guilt, preferring to wait for a jury to decide.

He blamed drink on the later problems that developed in his life and when living with his parents in Derby as a schoolboy he gave them the minimum of trouble and was described as a homely youth'. The local newspaper had amazing access to his letters and was able to provide its readers with something of insight into the man who changed because of fondness for drink and his disappointment in love.

Gough had, strangely, joined the police force in Leeds and formed a strong attachment to a young woman who lived in that city. But true love can sometimes be one-sided and in this case the woman decided the next field was greener and she wrote Gough a 'Dear John' letter.

He felt he had been deceived and decided the best thing he could do was join the army and head off to India and forget the woman he loved. He joined the 17th Regiment of Foot and was highly thought of, being described as a 'well-conducted steady man' and before long he received good conduct stripes to add to his 'excellent character'.

But, according to the *Derbyshire Times*, Gough 'mourned the one he had loved. To see Gough as the soldier, as the pedlar and as the convict, would indeed cause one to reflect on his varied career and the evil which has wrought his ruin.'

The trial over, the conviction established and awaiting the execution, Gough had plenty of time to reflect on his life and the problems he had caused himself. A few days before his execution, Gough's brother and sister visited him for probably the last time. His family, along with several prison officers, went into the condemned cell – one of two in the prison.

He shared his cell with three other convicted men all awaiting the hangman. There was a man named Manwaring who shot and killed a policeman in Derby two years earlier, a man who murdered a woman nearly eighteen years before and a third man who killed a match-box girl in the previous year. How these three were still waiting to be executed can only be described as a marvel of the legal system.

He shook hands warmly with his brother and embraced his sister 'with much emotion'. The couple were greatly shocked at the appearance of their brother,

which is not surprising. He told them he was better than he had been 'thanks to the kind treatment I am receiving from everyone here'.

The brother had brought with him a letter written by Gough's aunt in which she urged and pleaded with him to confess to the crime and 'seek forgiveness for it without delay'.

The brother then asked, 'There is one thing I particularly want to ask you and I hope you will tell me the whole truth.' Gough replied, 'What is it?' 'I want you to tell me plainly, did you commit this crime for which you have to suffer?'

Gough did not reply, but went to a small table in another part of the cell and took from underneath a Bible a letter he had written. He returned with it and told his brother, 'You have my answer here.' But before the brother could read it one of the warders stood up and demanded to be shown the letter first. He read what turned out to be a full confession of the killing.

One may wonder how the *Derbyshire Times* became privy to written information, which was seen only by the brother and sister, the prison governor and the warder. He did not want to talk about the crime but decided it would be easier to put into words how he felt.

It turned out that his sister allowed the *Derbyshire Times* to view and publish the letters to 'correct a wrong impression' of her brother reported during the early stage of his case.

But his brother asked, 'Where did you do it?' Gough replied, 'I did it in the lane where I was seen with her. It is a bad job.'

'How could you do such a thing?' his brother asked and Gough told him, 'I had no intention of doing it. The child followed me up the lane, and having committed myself I became reckless and did the job.'

'And is it true that you had the body of the child in the cart at the time you went into the Miners' Arms at Brimington Common for that glass of beer?' asked his brother. Gough replied, 'Yes it is true. The body was in the sack and the children were playing round it. It was mysterious that I should have done such a thing; but I felt so reckless that I did not care what became of me.'

It appears that Gough went on a modern-day pub crawl from first thing in the morning on an empty stomach. There were reports that he had drunk fourteen cups of rum and he told his brother, 'Oh, I had a lot of drink that day. I went out in the morning without any breakfast intending to go to Clay Cross. I started for there, but unfortunately for me, I changed my mind, and turned back. If I had gone to Clay, I should never have come here. It is a bad job, and I must now make the best of it.'

The time had come for Gough to say his farewell to his brother and sister. He broke down sobbing as he held her and when they left he was 'overwhelmed with grief'. The couple said their brother had accepted the punishment for what he had done.

In one letter that he wrote to his sister, a letter which was given to her on the day he was executed, he spoke of killing little Eleanor Windle, and said, 'It is fearful to look back to. I am very sorry for it. If I had a hundred lives, I would give them all

to call back that sweet little girl back to life but I cannot.' He said he had been 'so unfortunate to let his sinful heart commit such a fearful crime'.

On the afternoon before the execution, Marwood, the executioner, arrived at Derby Prison ready to prepare himself and his contraption of death for the gruesome task that lay ahead.

The great wooden scaffold could be seen from Gough's cell window and the place where it was erected was inside the prison graveyard. Whoever designed the whole site must have had a streak of cruel humour going through him.

There were already six graves of others whose lives were taken for whatever offence in the long list of crimes that attracted the death penalty.

By now Gough was on his last walk with the prison chaplain, Revd Henry Moore, at his side, reading the appropriate passages from the Bible. There was the governor, Captain Farquharson, and Mr Benjamin Peacock, the foreman of the jury that convicted Gough. Places at the scene of the execution had also been found for six members of the press.

He was taken into the pinioning room where his arms were restrained and then out into the yard to see the gallows close up for the first time. One journalist wrote:

As the dread structure appears in sight Gough gives a slight but nevertheless perceptible start, the only occasion on which he shows any sign of fear of the dread ordeal which awaits him.

Without any assistance, without any trepidation, he ascends the few steps leading to the gallows platform and takes up his stand underneath the rope from which his corpse will soon hang. He casts a long, wild glance at the warders, at the officials and at the graves at his feet, and then resigns himself into the hands of Marwood who had followed him onto the scaffold.

His legs are strapped together and the white cap is placed over his face midst an intense silence. Next Marwood adjusts the rope around the culprit's neck and draws tight the noose. All is nearly over now. The executioner steps back from the condemned man, draws the lever and a dull, heavy, sickening thud proclaims that it is all over.

The drop has been an eight foot one and the man appears to have died without a semblance of struggle. The surgeon, stepping forward, peers into the pit, now also a grave, and seeing that life is quite extinct makes a communication to that effect, whereupon the black flag is run up in the front part of the jail.

At eight o' clock outside the prison a small crowd gathered in the rain half an hour before Gough was to meet his death. As the hand of a nearby church clock ticked its way to the appointed time, muffled bells chimed the solemnity of the occasion. As the hour was recorded there was a crushing sound from within the prison – one indication to those outside that Gough had died.

Alfred Gough, a thirty-four-year-old with a commendable army record, a good education and a job as a policeman in the Yorkshire city of Leeds, was no more.

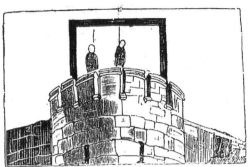

Trial and Execution of Wm. Reynolds Aged 18, and Wm. Marshall Aged 21, who were executed on the New Drop, at St. John's Prison, Nottingham, on Wednesday August 24th, 1831, for ravishing Mary Ann Lord.

THE unfortunate men who have this day forfeited their lives to the offended laws of their country were found guilty of commiting a rape on the body of Mary Ann Lord, and also threatening her destruction, as will be seen by the following report of the trial, which took place on Thursday the 21st of July, before Sir Joseph Littledale, Knight, in the Town Hall, Nottingham, when the prisoners were arraigned at the bar as follows.—William Reynolds Aged 18, Wm. Marshall Aged 21, John Spowage, Aged 17, and Thomas Cannor, Aged 24, severally pleaded not guilty to a charge of rape on Mary Ann Lord, on April 16. Mr. Balguy conducted the case for the prosecution, when Mary Ann Lord was called forward who appeared a simple looking girl, deposed as follows

She lived in Wood Street with her father and mother, near the Lord Rancliffe public house, she went from home on an errand, on the night of April 16th, to Mr. Clarkes in South Street, this was about 25 minutes past Ten; on returning through Platt Street, she saw some chaps come out of the Goat's head,; she observed them following her, and heard them laughing; when she got to the first house in Wood Street, one laid hold of her, the other three stood two or three street ends off. Reynolds put his arms round her neck and stopp'd her mouth, she then called out for her mother and Mr. Burton who is a constable, the other three were peep-bo-ing at the corner of a street to see how he was going on, he took and dragged her along, saying,' you're d—— strong, and if I can't deal with you, there's more as can;" he dragged me along way up the close, did all in my power to get away, I scratched his face, I squealed out again, he said he had got Moll, and he would have his will. He threw her down. The witness then with great reluctance detailed what ensued Reynolds then whistled, and said there are more coming up, and Spowage came up, Reynolds still holding her down. The witness then detailed the offence committed successively by the prisoners, Spowage, Marshall, and Cannor. They all wanted to drag her away to Long-hedge-lane, and said they would put her down a well in the field. Rachael Cope then came up with a man that was drunk, named Richard Jones, and the four men ran away in different directions; the woman helped her up, and adjusted her clothes; she said it's poor Ann Lord—Ann do you know me? witness said she did not know them; she then went to Mrs. Steer's, who lives next door but one to her mother, and there Rachael bid her good night; her mother was there, and they went home together directly. Witness said to her mother they had been doing what they deserved hanging for, her mother then knew what had been the matter, she took witness's gown to Mrs, Steers, This was saturday night, on Sunday afternoon witness told Mrs Steer she had known the men long time before, had often'teen them at the end of Robin Hood yard they had often insulted her before. Mr. Williams cross examined the witness at great length, but without at all shaking her testimony.

Mrs. Mary Ann Lord the mother of the persecutrix sent her daughter on an errand on the night in question, when she returned witness was at Mrs. Steers when they got home witness said, Ann what has kept you so long? she said she had been ill used, observed her gown hang ragged, she was dirty, mauled, and fainty; asked her who had ill used her she said, she knew two by name, and two by sight, and said they had done what they deserved to be hanged for; witness continued her evidence at great length which corroborated that of her daughter.

Mary Norman the landlady of the Goat's head, saw the prisoners on the night in question, but does not know whether Cannor was there, the other three was drinking at her house.

Robert Davison, Surgeon saw Mary Ann Lord on the Tuesday at the Police Office by the request of the Mayor, afterwards examined her, and was induced to believe gross violence had been used. Booth, constable described the close being within the limits of the town, saw Reynolds on Sunday morning, observed his face very much scratched, on Tuesday he apprehended Marshall, and his face was a little scratched. On the part of Cannor Sarah Smeeton was called to prove that he was at his mothers from ten till two in the night in question, Mary Holmes lives next door to Cannor's mother, saw him at home at half-past eleven o'clock.

The learned Judge very carefully recapitulated all the evidence, comparing its various bearings, a few minutes before 10 o'clock the Jury retired, at 11 brought in a verdict of Guilty against Reynolds, Spowage and Marshall, and of not guilty in regard to Cannor, Sentence defered till Tuesday morning, when his Lordship summoned the prisoners to the bar, Reynolds and Marshall where first called, when the awful sentence of death was pronounced upon them in a most solemn manner, afterwards death was recorded against Spowage from a recommendation of mercy from the Jury, on account of his youth.

The prisoners received their sentence with little or no appearance of emotion, and on being removed from the bar Marshall shouted, beware of Mary Ann Lord, "she's a second Fanny Blair."

Sir Joseph Littledale before whom they were tried, granted a respite which was forwarded from Warwick, on Sunday the 7th of August and reached the hands of Mr. Vason, the worthy Jailor, on Monday morning about 10 o'clock for 14 days.

At 11 o'clock the bell of the prison began to toll, and in two or three minutes the unhappy men came forward ready pinioned, with the halters about their necks and their caps on. They sat for a few seconds, and then knelt down to prayer, on account of his youth, Spowage from a recommendation of mercy from the Jury, on account of his youth. They sat for a few seconds, and then knelt down to prayer, the Rev. Chaplain engaged. This being concluded they rose cheerfully, and took their leave of those who had attended them.

Printed by W. Horsley, Derby.

Reynolds was first led out; the executioner having secured the noose to the beam, Marshall followed, and was also tied up with equal dispatch. Both of them recognised some of their old associates in the crowd, and smiled; Reynolds said to one addressing him by name, in a loud and clear voice, "Take warning by my unhappy fate." All being prepared, the Chaplain stepped to the front of the platform and said, "I am requested by the prisoners to state, that they die acknowledging their guilt and the justice of their sentence, and that they hope all here present will take warning by their fate; at the same time requesting an interest in your prayers." The prisoners then kissed each other, and took hold of hands,—the cap was drawn over their faces—the sound of their voices was audible in earnest prayer—the Chaplain commenced reading, "In the midst of life we are in death"—and, at the given signal, the platform sunk from their feet, and their eyes were closed for ever on the objects of this mortal life.

LAMENTATION.

'Tis done! the time has now arriv'd,
'Tis time no more to be;
For all that must employ our mind,
Is vast eternity !
Our deeds each tongue refuse to speak,
'Tis base beyond degree!
A blush spreads o'er the modest cheek
Whene'er they think on we!

We violated every tie
Which nature holds most dear,
A female robb'd of chastity
And beeded not her tears.
The cause was drunkenness alone !—
We should have shrunk with shame
In sober hours, if any one
Had chane'd the deed to name!

But fir'd with drunkenness and lust
We deeply plung'd in crime!
Our life's a forfeit—and we must
Die in our youthful prime!
Oh had we spent the Sabbath day,
As Sabbaths should be spent.
And join'd thy saints to praise and pray,
We should not now repent!

Had we but choose the wiser part,
And given to God our years;
Spar'd then had been our broken hearts,
And spar'd these falling tears.
But ah! religion was our jest,
The bible was our sport.
The brothel was our place of rest,
The alchouse our resort.

Our conversation base and foul,
With filth obscenely hung,
And curses on our precious souls
Were ever on our tongues!
Art thou a swearer?' reader, say—
Art thou a drunkard too?
Ah turn not scornfully away—
For we were two of you.

No hopes of mercy in this world,
The Judge held out to we;
But on our heads this sentence hurl'd,
That we should hanged be!
Then oh! may mercy from on high,
Save us from endless death!
For this we'll raise a fervent cry,
With our expiring breath.

Nowadays, the identity of a sex attack victim is not publicly disclosed.

2

I DON'T KNOW WHY I
KILLED MY FAMILY

The murder of children is such a heinous and horrific crime that it is looked upon by all right-minded people with revulsion and outrage. The killing of young people is made that much more dreadful because they are unable to defend themselves against an adult who is determined to do them serious harm.

Such was the case at the village of Colwick, not too far from Derby, in May 1844, when William Saville calmly slaughtered his wife and their three children. He never gave a reason for the terrible and brutal crime he committed.

This was another 'babes in the wood' type of killing and they were found by a man out hunting rabbits. Harriet Saville, aged seven, her sister, Mary, aged five and their toddler brother, Thomas, only three years old, were discovered lying side by side, soaked in blood from straight razor slashes across their throats.

Not too far away was the body of their thirty-eight-year-old mother, Ann, also with her throat slashed, and a blood-stained-razor in her hand. It was carnage that no right-minded person would ever want to see, and the man who stumbled across this scene of butchery was so horrified by the gruesome sight, that it remained imprinted on his mind for the rest of his days.

John Swinscoe, a framework knitter in the clothes-making industry, had gone out with his son, Abraham, on Thursday 23 May 1844, two days after the killings, to hunt rabbits for their family meal that evening. As he walked through the trees of Colwick Wood on that pleasant spring morning, he came across the children and thought they were asleep.

Thinking it strange that they should be out on their own, he went a little closer and found that the little ones, with their clothes, faces and hair covered in dried, blackened bloodstains, were, in fact, dead. He called to his son, 'Oh, Abraham, Abraham; I have seen such a sight,' and told him to run and fetch the local constable.

While the son was away, Mr Swinscoe was concerned that grass nearby had been flattened and when he followed its path, came across the body of the children's mother. He was too frightened to go much closer, but did notice she had a razor

held lightly in her left hand. She had also been dead for at least forty-eight hours and, like her children, was covered in dried, matted blood.

She appeared to have been dragged some distance. A shoe was found between Ann and her children and another was on her foot.

The constable turned up and made arrangements for a local doctor to come to the scene to officially certify that all of them were dead. In the mid-nineteenth century, doctors and surgeons did not have the skills or facilities to cope with such a tragedy and would have been overwhelmed by what is available in the twenty-first century and taken for granted.

Nowadays, detectives would arrange for the wood to be sealed off from prying eyes and white tents would be erected over the bodies. Scene of crime officers in white paper suits and special covers over their shoes would scour the area for clues, and doctors and pathologists would set up their equipment and examine the dead bodies in the isolation of the tents.

A search was made for husband and father, twenty-nine-year-old William Saville, and he was eventually found in a local ale house. He did not put up a struggle and went willingly with the constable to the local lock-up. Henry Freeman, a soldier in the 32nd Regiment of Foot, was also there and knew Saville.

They talked idly for a while and Freeman asked Saville why he was in the lock-up. Saville's attitude was strange and secretive but he talked about murder although he would not say more than he thought was safe. He confessed to Freeman that his case was 'curious and some people called it murder'. Freeman turned and faced his companion, curious to know more and wondering why someone should offer tell him about a murder.

Asked who he had murdered, Saville looked up from staring at the cell floor and without any fear told the soldier the victims were his wife and children. He also said that he was 'in pretty good tune for running that morning' and if the police constable had turned up half an hour later he would not have caught him. The constable did not have to walk too far because he found Saville drinking in the local watering hole.

Another prisoner who heard the two men talking interrupted and said, 'There is a report that they are drowned.' Saville by now appeared to have lost some of his composure and snapped at the other man, 'It is a lie; they are murdered.'

By now Saville had become a little bolder and when the other man was taken away he turned to Freeman and in a matter-of-fact way confessed to him a dreadful, heart-rending story of how he slaughtered his family and ended the lives of his children so young.

He spoke quietly, as if he did not want anyone else to hear his appalling, hideous story. It was as though he was sitting in a confessional when he related a story that brought a look of fear to his companion's face. He told how he, his wife and the youngsters decided to go to Colwick Wood. The killings had been planned and to make sure the children did not see anything he sent them away to pick flowers but it was unfortunate for them when they returned before their father could dispose of their mother's body.

When they saw what had happened they screamed. He told Freeman he was scared their screaming might attract someone to the area and they would find out what he had done. He said he was 'obliged to serve them with the same sauce', and one by one he grabbed each child and cut their throats in the same manner as he had their mother's.

The only sound in the quiet wood was the gurgling noise from the throats of each child as their blood slowly pumped out of them and they died.

He murmured to Freeman that as he was his only friend and trusted him with the awful secret and hoped he would not betray him and tell someone. But the whole situation weighed heavily on Saville and within a short time he repeated the same story to his father and another policeman. Each time he would not say why he had killed his family in such a terrible way.

In the current legal system, Saville might, at best, have been considered mentally unfit to plead to such a large number of killings and at worst would have denied murder but admitted manslaughter on the grounds of diminished responsibility.

But in an early-nineteenth-century system, where everything was black or white, the choices available to a defence barrister were very limited. Medical conditions played no part. It was either plead to murder or take a chance and deny all charges of murder and go to trial. That is what Saville did.

The trials were something of a travesty or mockery; nothing like we see in our modern-day courts. In 1844 it was a lottery, whereas today everything would be done for the benefit of the defendant.

Saville's trial started at the spring assizes at Nottingham county hall. Numerous prosecution witnesses were called to tell what they knew but none gave any evidence about Saville's behaviour in the days before he murdered his wife and children. There were none to say whether they had heard him make threats against their lives. There were no defence witnesses.

The evidence came to an end and the judge summed up. The jurors listened intently to indicate they were somewhat overwhelmed by his stature in the court. He completed his review of the testimony and told the jurors it was time for them to retire and consider their four verdicts.

They silently filed out of court, to a room specially set aside for them away from the courtroom, and settled down to reach a verdict after diligent and wise consideration. Their discussions lasted only eighteen minutes and they let it be known that had reached verdicts and were ushered back into court.

The clerk to the court asked the jury foreman for the decisions and one by one he returned a guilty verdict on each of the four charges.

Saville was told to stand in the dock as he was addressed by the judge who told him:

You have been convicted of a dreadful murder on the clearest of evidence. No person who has heard the evidence can entertain the slightest doubt of your guilt.

You have destroyed the wife of your bosom, whom you had sworn to protect. I am afraid the state of your mind is such that you do not regard the crime with any horror or with any feelings of compunction.

(This comment suggests that the judge thought there might have been some abnormality of Saville's mind.)

He went on:

> It is not my intention to enlarge upon this subject; I am afraid it would be of little use. When you are taken back to prison to prepare for the expiation of the crime you have committed, I hope the time will be diligently employed by you in preparation to give effect to that expiation. No person has a right to take the life of another, and the law provides that those who do so wilfully shall themselves suffer death. It would be an idle hope on your part to indulge in expectations of mercy.

(Whereas today judges would make reference to the murders of the children, nothing was mentioned of them as their father was being sentenced.)

A local journalist reporting the case wrote, 'During the passing of the sentence the crowded court was very still; and the intense silence was not broken till the sentence had been passed, and the prisoner was about to be removed from the bar. However, he was firm throughout, and during the passing of sentence continued to be attentive, but apparently devoid of feeling.'

As he waited in the condemned cell at Derby prison for his execution three months in the future, Saville kept himself to himself and continued to 'display the same firmness he has evinced ever since his apprehension'.

Saville was a troubled man but kept his feelings under control and refused to explain why he had wreaked such violence on his family. It is doubtful that it was a spur of the moment series of attacks, but his behaviour kept begging the same question – why?

Saville could have harboured a death wish. He said he was well-satisfied with the way his defence was conducted, and said he could have brought witnesses to have disproved much of the evidence, but he would not.

What was he trying to prove? Any man whose life is at stake will do everything possible to save it by calling as many witnesses as possible. Why was he prepared to die? His mental capacity was questionable judged by his behaviour before and during the trial. Saville was prepared to die and take his secret with him to the grave.

As his execution date drew nearer he was said to have taken a great interest in religion. He frequently took part in prayers, and read the scriptures but still refused to say why he killed his family. He was heard to say the only reason people wanted to hear his story was because 'they only wanted to get a tale to cry about the streets'. He said he was not prepared to do that.

On the eve of his appointment with the hangman, Saville was 'reserved and seldom talks unless he is spoken to'. He had talked to his brother-in-law in a 'very common-place manner, not displaying the least emotion'.

On the day of the public hanging 'the interest excited about the execution has been beyond all precedent; every avenue having a view of the drop, was taken

possession of at an early hour. As the prisoner ascended the scaffold attended by the chaplain, after a short time spent in prayer the executioner having prepared the fatal apparatus of death then descended, and in a few minutes the bolt was drawn, and the wretched man after a slight struggle, was launched into eternity.'

His body hung in view for at least half an hour and then after an inquest he was buried within the walls of the prison.

Saville told people he did not plan to make any confessions. That would be settled between God and himself.

3

HE LOVED HIS BROTHER'S WIFE

Poison is a silent, creeping killer. It pollutes and corrupts a healthy system and within hours its lethal powers will strike down all the vital organs and leave the sufferer wracked with pain and confusion. The longer it takes to die, the greater the pain, and death is a merciful release.

Arsenic is probably the most well known. Although it is in harmless in minute amounts, occurring naturally in water and an element around us all the time, it only releases its deadly results in larger quantities. It is odourless and the only suspicion a sufferer might notice is a metallic taste when food is laced by the murderer. The food is usually pushed aside but a relentless killer will make sure that what he has started will be finished one way or the other.

Thomas Grundy was one such person and in 1788 he decided to poison his elder brother, John, with whom he lived in the village of Dale Abbey, Derbyshire. John was married and it was suspected among the villagers – although never proved – that the younger sibling was having an incestuous relationship with his brother's wife.

The illicit, secret love affair was carried on over nine months and was something of which John Grundy was unaware. Had he known about this quaintly called 'incestuous connexion' it would be safe to assume that he would have kicked his brother out of his home and escaped what sadly proved to be his 'destructive end'.

A small, unexpected incident in what can be described as a close-knit community is often a breeding ground for gossip and rumour and the bush telegraph will soon spread a story that begins to grow and take shape.

Two men, and the wife in this tragic love triangle, shared all the amenities that the comfort of a house offered, but Thomas Grundy needed to take it further, into the realms of adultery, something that courted ultimate disaster.

Thomas Grundy wanted his brother's wife, and for this he was prepared to breach another of God's commandments – Thou shalt not kill. As a local scribe later wrote as a permanent memorial, 'It appears from the best accounts of this

melancholy affair, which this unfortunate brother stood as a bar to his wishes, and consequently his removal seemed to be resolved on.'

A person to whom arsenic is administered will usually die within half an hour of taking the highly dangerous natural element; the first signs of approaching death begin to show immediately. A victim will begin to salivate excessively, have problems swallowing, sweat, vomit, and suffer cramps, seizures and kidney failure.

The skin and lungs will be affected, the blood vessels and immune system will be next and gradually the poison seeps into other parts of the body, causing hair loss, anaemia, damage to the reproductive organs and can also cause cancer if the victim is lucky enough to survive.

Obviously twenty-year-old Thomas Grundy was not aware of the insidious nature of arsenic but he was fully aware that it was often used to kill rodents, so he must have known that his brother could have died. On the day he decided to murder his brother in March 1788, he got up early and was out of the house and finished dressing himself in the street as he rapidly made his way to Derby.

The local scribe later wrote, 'The morning that the poison was administered to the deceased, Thomas Grundy was observed to rise earlier than usual nay, in such a hurry was he to go to Derby in order to purchase the poison, that he could not wait in his bed-room until he had dressed himself that be brought part of his clothes and put them on in the street, and immediately set out for the horrid purpose. On his arrival at the druggist he desired to have some arsenick [sic] which he said was to poison rats.'

He was given the poison and returned to Dale Abbey as fast as possible because it was the day of the annual Wakes Fair at nearby Shipley 'and it seems an assignation had been made with his brother's wife to visit that place of feasting and jollity; his scheme therefore seems to have been to administer the fatal drug before they departed, so that his brother's death happening in their absence, might prevent suspicion being thrown upon them'.

The person who wrote about the birth, parentage, life, trial and confession of the younger Grundy, seemed to know more about the plan to kill the older brother and the part his wife was alleged to have played in the murder of her husband.

John Grundy made plans the day before his death to visit a wedding celebration at a nearby church but before going made it clear to his wife that he wanted her to prepare some cold mutton with hash potatoes for dinner before he returned home.

She went to fetch him from a local pub where he had gone for a drink, and while she was out the younger Grundy took the opportunity to mix some arsenic into his brother's meal, which had been placed near to the fireside to keep it warm.

It appears from evidence during the trial, to which I shall make reference later, that Thomas urged his sister-in-law and lover to leave the house so her husband would be encouraged to return from the pub, and leave him the short time needed to pound and mix the arsenic in the hash and mutton in preparation for his death.

The younger Grundy took his brother's meal from beside the fire where it was being kept warm and slowly sprinkled and pounded the white poison into the food. A neighbour claimed he heard noise of banging and another told the trial jury that he saw Thomas Grundy emerge from the house on several occasions as he waited for his sister-in-law and his brother to return home.

She returned to the house before her husband and, having 'executed this diabolical scheme', the so-called adulterous couple left the house to make their way to Shipley and an afternoon of carefree enjoyment and extra-marital pleasure while John would eat a meal that would eventually take his life.

Death waited in the shadows for John Grundy as he returned home a hungry man; followed by his mother with two children she was looking after who had lost their mother. For some reason he was not looking forward to his meal and decided to offer some to the youngsters.

The writer of the life of Thomas Grundy described what happened, 'He, not relishing his repast, offered some of it to the little innocents, one of whom, on tasting the same, refused to eat, but the other swallowing some portion of it soon became sick and threw a great part of it up, and a proper antidote being applied, is happily recovered.'

By now John Grundy had begun to eat the poisoned meal and was taking the first step towards the end of his life. He urgently called for help 'on being seized with racking [sic] pains' complained to his neighbours that he was taken in such a strange way that he never experienced the like before, and thinking a little warm ale might ease him, he returned to the public house and drank a pint, which in no doubt accelerated the effects of that deadly drug.

Slowly the arsenic increased its ever-tightening hold over his body. The needle-sharp pain made him sweat profusely and he began to weaken. He found it difficult to breathe and swallow as cramp and seizures gripped him like a vice.

His brother and the wife he coveted returned from their afternoon of pleasure at Shipley Wakes, to find John Grundy dying a slow, painful death. He pleaded with his wife to get help as fast as she could and the cheating woman urged her lover to go to a shop at West Hallam to fetch some oil and other potions that might help her dying husband.

But Thomas Grundy was frightened of the dark and would not leave unless someone went with him. His mother managed to locate a young boy nearby and offered him some money to accompany her lover to the shop. On the way the boy noticed how frightened the older man had become, as he pleaded with him to take hold of his coat lapels as he was afraid to go any further.

However, Grundy still had some of his wits about him and to encourage the boy's help told him that his brother would die and that the youngster could have an apprenticeship and live in the house.

The following morning John Grundy told a neighbour that he had taken something to help his condition and felt a little better, but within hours he was dead. That was how arsenic worked.

By now Thomas Grundy realised how perilous his position had become. He packed some clothes but before leaving was asked by a neighbour what was going on. He foolishly confessed in part to what had happened and said he bought the arsenic while someone else pounded and mixed it. That was as far as the admission went and still unable to grasp what had happened, he left his brother's house and made off towards Nottingham.

On the way to the City of Lace, Grundy stopped at a beer house for some refreshment and asked for some bread and cheese and a pint of ale. But something bothered him and 'much alarmed', he fled, leaving most of the ale behind him.

He reached Nottingham several hours later, slightly ahead of the law, and went to a pawnbroker's shop where he sold or exchanged his coat and waistcoat, 'telling the proprietor that he was running away from two bastard children and desired that they would not discover him'.

Grundy decided to head for London, well over 100 miles away, where he might be able to disappear among the thousands who lived in the capital city. However, after walking only a short distance, he decided instead to return to Nottingham into the arms of those searching for him and his arrest. It had not taken the authorities very long to catch up with the fugitive. 'The noise of this murder having reached by means of hand bills, dispersed for this purpose, he was soon apprehended, brought to Derby and committed to the county goal by coroner's warrant.'

He was questioned several times about the death of his brother but 'notwithstanding his want of education, he appeared no ways wanting in abilities, giving such reasons for his innocence as astonished the magistrates'.

On Wednesday 19 March 1788, Thomas Grundy appeared at Derby Assizes for trial in front of Baron Thomson and a jury. Very little was reported of the trial for public consumption, but the courtroom was crowded by the curious.

His evidence was short and simple. There was a 'fair, candid and impartial hearing', which lasted about five-and-a-half hours. But in the majority of cases during the 1700s and 1800s jurors had the amazing skill of going through the evidence with speed, so that within minutes they had found him guilty of murder and he was sentenced to death. To go to a room and discuss all they had heard was something that would only happen way into future.

The judge, Baron Thomson, was adorned with the black cap – a square piece of material – as he prepared to pass sentence 'which he did in such a solemn and pathetic manner, as to draw tears from almost every hearer, except the prisoner, who stood the shock with great resolution, frequently interrupting the judge, by declaring his innocence. His lordship expatiated largely on the heinous offence he had committed; and observed he was an unnatural monster, to be guilty of taking away the life of one so nearly allied to him, even his own flesh and blood. He begged him to make the best use of the short time allowed to him to prepare for eternity.'

During the next three days – although he was not aware of the date when he would be executed – Thomas Grundy was visited by people and persisted in pleading his innocence and that he had nothing to do with his brother's death.

1851

The Trial and Conviction

OF

SARAH BARBER, 22,

Who now lies under the awful Sentence of Death, in Nottingham County Goal, for the Wilful Murder of (her Husband) Joseph Barber, at Eastwood, Nottinghamshire, on the 24th of March last.

Together with the Judge's Address.

The Eastwood Poisoning Case.

Sarah Barber, 22, dress-maker, and Robert Ingram, 19, butcher, charged with the Wilful Murder of Joseph Barber, at Eastwood, on the 24th of March, 1851. The Court was filled by a great number of persons. The female prisoner, who, for her extraordinary height (six feet three inches), was dressed in deep mourning. Neither of the prisoners seemed to be much affected, and pleaded 'Not Guilty,' in a loud unembarrassed tone.

Mr. Macaulay, Q.C. and Mr. Denison appeared for the prosecution; and Mr. O'Brien and Mr. Crockle defended the prisoners.

Mr. Macaulay opened the case to the jury; and called Mr. William Scott Smith, Mr. Gossett Browne, Mr. T. Wright, M.D., and Mr. Taylor, Surgeons, proved the presence of arsenic on the stomach of the deceased, Jos. Barber.

Elizabeth Barber said,—The deceased was my son. I am a widow, and live at Newthorpe, which is about a mile from Eastwood. He was 35 years of age, and was a horse dealer and higgler. He had been married to his wife (the prisoner) for five years, but she had no family. I received notice from the prisoner on the Wednesday that my son was ill. I received word at 11 o'clock, and accordingly immediately went to see him. I saw my son up stairs, and he said he had been very poorly that night, but was much better. He complained of his mouth being dry and parched, and that he was thirsty. He did not tell me that he had been sick. The wife came up stairs and told him that he had a bad night of it, and then went down again. My son asked me to make him some gruel, and I, therefore, went down stairs, and having prepared some, I gave it to him, and he drank about a pint. He said it was very nice, and much better than they made it, and that the gruel they made him was nasty. During the time I stopped there that afternoon, he became much better. After he had had the gruel, he had some water and a little preserve that was in the room. During the time I was there he was never sick but once, and then he threw up about two tablespoons full of gruel. This was at about two o'clock in the morning. He was not purged during the time I was there. She once went away from home in consequence of my being there. That was about five weeks before my son was taken ill, and she staid away two nights. On the Thursday, my son appeared to be so much better, and at about eleven o'clock, when I went away, he was talking of having a cup of tea and a new laid egg. After leaving him I went home to bed, and about three o'clock next morning Ingram and a neighbour named Shaw came to tell me he was dead. While I was in the bedroom on the Wednesday, Ingram gave my son some medicine out of Mr. Smith's bottle. I know it was Mr. Smith's bottle cause my son told me to give him that. My son did not tell me he would not take Bowker's medicine because it made him sick. It was about four o'clock when my son took Smith's medicine. Ingram came up stairs with a bit of coal and poured out the medicine for him, and he took it.

In the morning my son said to ___ wife, "Sally where are the preserves." (By Mr. Macaulay.)—I know my son's wife went to France with a man named Gillott.

John Shaw having been sworn: I reside at Eastwood. On the 14th of March (Friday), I was asked by the prisoner Ingram to accompany him to Cullen's shop as a witness, as he wanted to buy some arsenic to poison the mice, and Mr. Cullen would not sell any unless there was a witness. I accordingly went, and saw Cullen sell him a pennyworth.

Professor Taylor, in answer to Mr. Macaulay, said that that would be about half an ounce, or about 215 grains.

Shaw's evidence was then continued:—I was in Barber's house on the following Sunday, and asked Mrs. Barber if she had found any mice that had been poisoned? She said she had burnt the arsenic, because if her husband were to die suddenly, people would say he was poisoned, and she would therefore not have it about the house. On that day I heard the female prisoner ask my wife whether she would say she had seen her burn the arsenic, but my wife said she would not tell a story for any one.

After many other witnesses were examined his Lordship summed up the Jury retired, after a lapse of merely a short time, returned a verdict of 'Guilty' against SARAH BARBER, and of 'Not Guilty' against ROBERT INGRAM.

The Clerk of Assize (Mr. Cooke, who acted in the place of Mr. Collinson, who is seriously ill) then addressing the prisoner Barber (upon whom the verdict did not appear to make the least impression) said, to Sarah Barber, you stand capitally convicted of the crime of murder. Have you anything to say why sentence of death should not be passed upon you?"

The prisoner made no reply, and proclamation for silence have been made.

His Lordship put on the black cap, and passed the awful sentence as follows:—" Sarah Barber, the Jury who have just pronounced their verdict against you, have performed a most painful duty. They have, after a full consideration of the evidence brought against you, and after hearing a most able speech addressed to them by your learned Counsel, come to the conclusion that you have been guilty of the heinous offence with which you were charged. It remains for me to perform a duty painful to me, which fortunately I am now nearly called upon to perform, and that never, except in cases of an aggravated nature, to tell you that for the crime for which you have been justly tried and convicted, to tell you that you are to suffer an ignominious death upon the scaffold. You have been found guilty of the most awful crime that can be committed. You have taken the life of your unfortunate husband, by the most horrible and deadly means, namely, that of poison. I mention this that others may be deterred by your fate from being guilty of the like crime; and I (said the learned Judge) do it for the purpose of exciting you to think seriously of the dreadful position upon which you stand, and to implore Almighty God to lend you the grace of the Holy Spirit to enable you to repent sincerely, during the short time you will remain in this world. You will have the assistance of a Reverend clergyman in the gaol to improve your mind and dispose it to repentance and to enable you during the time you remain here, to make your peace with God, and to obtain that pardon which it is impossible for the sake of others you should receive in this world. Would that you had reflected upon the consequences before you had committed this act. Would that you had reflected that the laws of man reach such cases with destruction; you had purchased the poison to kill whom you were bound by your marriage contract to love, honour, and obey. It only now remains for me, as is my duty as the minister of the law, to tell you that you will be removed from hence unto the place from whence you came, and from thence to a place of execution, and you must there be hanged by the neck until your body be dead, that your body must be taken down and buried within the precincts of the gaol, and may the Lord have mercy upon your soul."

The prisoner, who, while the last dread sentence of the law was being passed, exhibited scarcely a single sign of feeling, at the conclusion turned round to the Jury, and said, "You have found me guilty in this world, but cannot find me guilty in the next world. You have found me guilty, but I am as innocent as a child."

The learned Judge thereupon said, " No one who has heard the trial can entertain a doubt of your guilt."

The prisoner was then removed from the bar.

(RANTS, PRINTERS, 35 CLARE STREET, NOTTINGHAM)

Poisoning was the worst form of murder, leaving the victim unaware of what was happening.

He denied he had run off after John died, saying that he was on his way to see a sister.

But as the eve of his execution drew near, Grundy knew that the time left to him was very short and he began to blame his sister-in-law. He confessed to a jailer that he bought the poison at her bidding and encouragement. He said she mixed the arsenic in the hash in front of him before they went to the Wakes.

It was now that Grundy went one step further and admitted that he and his brother's wife had fallen in love and lived a furtive and secretive incestuous relationship for nine months up to the murder.

Writers in the seventeenth and eighteenth centuries had a magical way with words and, on this occasion, Saturday 22 March 1788, it was said that Grundy was 'prepared for the awful summons, his irons knocked off and he received the sacrament from the hands of the Rev. Mr Henry'.

There was nothing decent about his last few moments of life. He was bundled into a cart pulled by a horse and driven past numerous spectators to the 'fatal tree' and there with the rope around his neck the cart was drawn away and he was 'launched into a boundless eternity'.

His body was allowed to hang as a grim warning and reminder to the local population that it was almost impossible to escape the powerful arm of the law. He was unceremoniously cut down after an hour or so and delivered to surgeons where, with even less ceremony, his body was used for dissection. Sometimes such dissections were public, but mostly they were for the benefit of medical students.

And so another love triangle ended with fatal consequences for two and nothing but sadness for a woman who planned to move to Ilkeston with a man who had killed his brother.

There was just one thing left: these lines from a budding poet, whose skill with words encouraged him to write a few lines on Thomas Grundy.

> *Who, (but the Wretch that has a Heart of Stone)*
> *Can't weep when Nature utters forth a Groan?*
> *Say, what's the Cause? 'tis MURDER! Horrid Sound!*
> *Man slain by Man, lies buried in the Ground;*
>
> *Amazing to reflect, that Man should be*
> *So base, to prove his greatful Enemy,*
> *They think t'escape, but God's uplifted Hands,*
> *With Vengeance waves, and Blood for Blood demands.*

4

BURNED TO DEATH FOR HER BELIEFS

The freedom to believe in religion has for centuries led to the cruel persecution of people who trust faithfully in something but are judged by others, fanatically and obstinately, devoted by passion to an opposing view.

Joan Waste was one of those victims. She was devout in her Protestant belief, which signed her death warrant and she was burned at the stake for heresy.

She lived in Derby and came from a poor but happy family. Her father, William, was a barber, who occasionally turned his hand to making ropes. She also had a twin brother, Roger. Joan's life was dealt a tragic blow from the day she was born – she was blind. But to a certain extent she overcame her disability and was able to seek comfort and happiness in her religion as a member of the Protestant Church during the reign of Edward VI.

On the death of the king in 1553, Mary, a Roman Catholic, became queen and for the five years of her 'bloody' reign, made it illegal to hold Protestant views. But because of her commitment Joan was persecuted and died a terrible death at the hands of religious fanatics within the Roman Catholic Church.

The story of Joan Waste began in 1534 when she was born in the All Hallowes Parish of Derby. As she grew up she was able, with the help of her parents and brother, to cope with her disability and to a great extent led as normal a life as possible.

She began to go to St Peter's church in the city – which later became Derby cathedral – to hear the ministers present their services and sermons to the congregation. Joan's needs were few but she craved a Bible to help her gain a greater understanding of the religion that meant so much to her.

But to buy her Bible she needed to earn money and she would sit at home for hours knitting woollen socks to sell from a stall on Derby market days. She eventually earned the pennies to buy her Bible, but because of her blindness she needed someone to read to her on a regular basis.

There were people prepared to help – John Pemerton, clerk of the parish of All Saints and others to whom she would pay a penny a time. But there was one particular man named John Hurt who was serving time in Derby's debtors' prison.

In Foxe's *Book of Martyrs*, first published in 1563, there is the history of the life, trial and execution of Joan Waste, and details of her relationship with John Hurt. He was described as 'being a sober grave man, being of thraescore and teene years, by her earnest entreatie and being prisoner, and many times idle and without companie did for his exercise daylie read unto her some one chapter of the New Testament...'

With the help of these people, Joan began to learn parts of the Bible by heart and 'she so profited that she was able not only to recite many chapters of the New Testament without booke, but also could aptly impugne, by divers [sic] places of scriptures as such abuse in religion as then were too much in use diverse [sic] sundrie persons, as this godly woman thus daily increased in the knowledge of God's holy word'.

Despite her lack of schooling, Joan soon developed the ability and skill to passionately argue with opponents of her beliefs. Those who opposed her watched and waited. King Edward was not a well man and early in 1553 he died. His place was taken by his Roman Catholic sister, Mary, who, as one of her first acts as Queen, made it illegal to hold Protestant views.

She became known as Bloody Mary and during the five years of her reign and the 'woefull ruine of religion', she committed 277 people to their deaths for heresy, among them Bishops Thomas Cranmer, Hugh Latimer and Nicholas Ridley – so for the wrong reasons Joan was in good company.

Foxe's *Book of Martys* stated 'notwithstanding the general backsliding of the greatest part and multitude of the whole realm in papism again, yet this poore blinde woman continued in a constant conscience, proseeded [sic] still in her former exercise being both zealous in that she had learned and also refusing to communicate in religion with those that taught contrary doctrine to that shee [sic] had learned in King Edward's time'.

Joan was placing herself in a worrying and dangerous situation by almost taunting those in power in the Roman Catholic Church. She persisted in ignoring the many warnings that her behaviour would not be tolerated, and made it clear her Protestant beliefs would in no way be changed.

Ralph Baines, the Catholic Bishop of Lichfield and Coventry, was her tormentor in chief, supported by Anthony Draycot, his chancellor and other members of the hierarchy which included Sir John Port, Henrie [sic] Vernon, Peter Finsh [sic] and two Derby bailiffs, Richard Warde and William Bembridge.

By now Joan had totally accepted Protestantism and was highly proficient in dealing with her accusers. Foxe's *Book of Martyrs* described her thus: 'Joan Waste ... was notorious that she being blinde, could notwithstanding, without a guide go to any church in the said city of Darbie, or to any other place or person whith whom she had anie such exercise, by which exercise she so profited that she was not only able to recite many chapters of the New Testament without booke, she

could also aptly impugne, by divers places of scriptures, as such abuses in religion as then were too much in use in diverse sundrie persons, as this Godly woman thus daily increased in the knowledge of God's holy word.'

King Edward died and when his throne was taken over by his sister, Mary, Joan refused to 'communicate in religion with those that taught contrary to that shee [sic] before had learned in King Edward's time'.

There was now no way out for Joan. She made her stand clear to the authorities and refused to accept church services being read in Latin; would not believe in the sacrament of the altar and that Christ's body was represented by bread and wine.

She told the Bishop of Lichfield that she 'believed only the right things taught by the Holy Scriptures and by Godly-believing men'. She further antagonised the bishop when she asked him, 'Are you prepared to die for your doctrine? If not, then for God's sake trouble me no more. I am but a poor, blind, uneducated woman, but with God's help I am ready to yield up my life in this faith.'

Bishop Baines and his chancellor, Anthony Draycot, angered at her defiance, threatened her with imprisonment, torture and death if she refused to believe in the Sacrament of the Altar. But Joan was adamant. Nothing they said or did would make her change her mind.

She asked the bishop in another daring and bold challenge that if he believed in his heart that his doctrine was true, would he be prepared to answer for her on the Day of Judgment. Bishop Baines said he would but he was contradicted by Anthony Draycot who said, 'My Lord, you do not know what you are doing. You may under no circumstances answer to God for a heretic.'

The bishop backed off, immediately realising his mistake, and told her to turn away from the faith of the Bible and trust only in the Church of Rome. He said it would be up to her to answer to God.

She replied, 'If you refuse to take on your conscience as true what you wish me to believe, I will answer you no more; do your pleasure.' The bishop had no choice. He had been placed in an unacceptable and embarrassing position and ordered the bailiffs to take her and confine her in the city prison.

Within weeks she faced charges of heresy. She was accused of holding the sacrament of the altar to be 'onlie a memory or representation of Christes [sic] bodie and materiall [sic] bread and wine, but not his naturall bodie. That she did holde in receiving the Sacrament of the Altar, shee did not receive the same bodie that was born of the Virgine [sic] Marie and suffered on the cross for our redemption.'

The Roman Catholic Church also said she refused to accept that at the last supper, Christ did bless the bread 'that he had then in his hands, but blessed himself [sic] and by the wordes of consecration, the substance was not converted into the substance and the bodie and bloud of Christ'.

Joan was fighting a losing battle against people with such passionate zeal who tried to make her accept their arguments of Christ's omnipotence. In 1563, seven years after Joan's execution, Foxe's *Book of Martyrs* recorded 'And many times being threatnd [sic] with grievous imprisonments, torments and death; the poore

woman thus being, as it were, halfe astonished through their terrors and threats, and desirous (as it seems) to prolong her life, offered unto the bishop then present that if he would before that companie take it upon his conscience, that the doctrine which he would have her believe concerning that Sacrament, was true, and that he would at the dreadfull [sic] day of Judgement answere for her therein, she would further answer them.'

Joan's defence for her beliefs reached deaf ears and the two men in front of her realised there was no choice but to sentence her to death. The bailiffs kept her in prison for a month.

As the day of her execution arrived, Chancellor Anthony Draycot arrived in church accompanied by supporters. With everything in place, 'the poore blind creature and servant of God was brought in and set before the pulpit' where the chancellor was in full flow with his sermon.

As the blind young woman was guided into the church and placed before Chancellor Draycot, he launched into a vitriolic attack against people he called heretics. He told the congregation 'that the woman was condemned for denying the blessed sacrament of the altar to be the verie bodie and bloud of Christ reallie and substantially and was thereby cutt [sic] off from the bodie of the Catholic Church.'

The attacking sermon increased in its intensity of scathing ill will and with her sightless eyes Joan looked up as the chancellor continued to heap insults upon her. He repeated to the congregation that not only was she 'blinde in her bodily eyes, but also blinde in the eyes of her soul'. His fire and brimstone vilification of a 'non-believer' went on without a break and said that, 'As her bodie should be presentlie [sic] consumed with material fire, so her soul should be burned in hell with everlasting fire, as soone as it should be separated from the bodie and there to remain world without end.'

He continued to rant and warned members of the congregation that it was not lawful for them to pray for her. The chancellor ended his verbal torrent and told the bailiffs to take her to her place of execution.

1 August 1556 was Joan Waste's last day of a life that, in its short years, was totally without harm to any other human being. She had enough to cope with and all she wanted in her twenty-two years was to be left alone to seek happiness in a religious belief she would not renounce and without the fear of threats from others.

She was taken by the bailiffs to Windmill Pit off Lime Avenue on the Burton Road in Derby, about a mile from the church. She walked hand-in-hand with her twin brother, Roger, to her place of execution and there, waiting for her, was a large pile of wood under a gallows.

She was hung above the wood as it was set alight and watched by a crowd as the flames burned through the rope and she dropped and disappeared.

Elizabeth I came to the throne in 1589 and Ralph Baines lost his job as Bishop of Lichfield and Coventry. He was sent to London and made a prisoner of the fleet and died in 1571 after his release.

Chancellor Draycot went to a nearby inn for a meal after his sermon and then fell asleep during the time of Joan's execution.

5

AN ANIMAL IN HUMAN FORM

The desire for sex – particularly in men – and the instinct for self-preservation are, without a doubt, two of the most powerful of human emotions. Forget sex but concentrate on the desire by someone intent on maintaining the status quo at all costs, which pushes selfishness to the extremities.

Trawling through ancient and discoloured historical documents at libraries and records offices in many parts of England is deeply satisfying and has unlocked a major part of the country's social past.

My research for this part of the book has uncovered a few little-known and sometimes well-hidden, strange and extraordinary stories. On a few occasions details of an event or incident may only be two or three lines, but can easily be missed. However, on further examination, they disclose bizarre events that happened two or more centuries ago.

One such incident occurred around the 1650s in Derbyshire, when horse stealing was potentially a capital crime. Many people were apparently prepared to risk their lives as the offence was committed with dangerous regularity and an increasing number of people had their necks stretched to snapping point at the end of the hangman's rope.

An overwhelming number of folk were so poor that living below the poverty line today makes people seem well off by comparison and living close to the 'top end of the hog'. But our ancestors had to live and feed a family and sometimes, with many children and little money, crime was the only way of getting the funds to buy food.

One such family was the Crosslands – a father and two sons – who were convicted at Derby Assizes of horse stealing. However, the judge who sentenced them was a man endowed with a streak so cruel that one cannot imagine why or how he came to the decision that put father and sons into a situation which pitted one life against the others.

The judge decided to grant a reprieve to one of the trio as long as he hung the other two. In a *History of Derby* written by William Hutton, he said the judge's

decision 'entertained the cruel whim of extending mercy to one of the criminals but upon this barbarous condition that the pardoned man should hang the other two. When power wantons in cruelty, it becomes detestable and one gives greater offence than even the culprits.'

Other judges in those days punished offenders with impunity and with a power that was savage and ruthless and made their right to dispense justice seriously questionable. Sadly, no-one cared. The lives of the poor were cheap and fodder for the hangman. There was no such organisation as Liberty to fight for them, or others to argue that their human rights were being abused. It was simple. They did not have any rights.

Hutton appeared to be the only person to make a record of what happened to the father and his sons, and a writer in a book called *Derbyshire Biographies* aired his views of the hangman, a man he described as 'a most inhuman and brutal fellow for the sake of saving his own worthless life.'

The Derbyshire biographer wrote, 'What a fine contrast is seen between the characters of the father and his first-born, and that of the younger son ... and how finely their love for each other shone out in their last extremity. Such men as the father and eldest son were fit to die – the younger was not fit to live.'

These powerful words of condemnation were matched only by the record kept by William Hutton, a rare account of how high the feelings ran against a man whose sole aim was self-preservation. His narrative and detailed description of the events that led up to the execution of the father and eldest son deserves a place in the county archives for all people to see.

He wrote:

About the reign of Oliver Cromwell or the beginning of Charles the Second, a whole family, consisting of a father and two sons, of the name of Crossland , were tried at Derby Assizes and condemned, I think, for horse-stealing.

(Here Hutton said that horse stealing was not a capital offence, but the sentence was one of hanging.) He continued:

The bench, after sentence, entertained the cruel whim of extending mercy to one of the criminals, but upon this barbarous condition, that the pardoned man should hang the other two.

When power wantons in cruelty, it becomes detestable, and gives greater offence than even the culprits. The offer was made to the father being the senior. As distress is the season for reflection, he replied with meekness: 'Was it ever known that a father hanged his children? How can I take away those lives which I have given, have cherished, and which, of all things are most dear?' He bowed, declined the offer and gave up his life. This noble reply ought to have pleaded his pardon.

It was then made to the eldest son, who, trembling, answered: 'Though life is the valuable of all possessions, yet even that may be purchased too dear. I cannot

ESCAPED

FROM

PRISON.

WHEREAS

GEORGE CROSSLAND

Alias GEORGE SMITH,

DISCHARGED FROM THE

Town Gaol at Leicester,

In October Last,

(Where he had been imprisoned Two Years for House Breaking by the name of GEORGE SMITH.)

ESCAPED FROM THE

GAOL at OAKHAM,

ON FRIDAY THE 29th OF DECEMBER, 1820,

About Four o'Clock in the Afternoon.

The said *George Crossland* alias *George Smith* was committed on Thursday the 28th Instant, for stealing a quantity of Drapery Goods, the property of Messrs. DEACON, HARRISON, and Co., from a Warehouse in Oakham: He describes himself as a native of Ecclesfield, or Sheffield, in Yorkshire, by trade a File Cutter; but he has lately been employed in hawking Drapery Goods.

He appears to be about Thirty-two Years of Age, Five Feet Six or Seven Inches high, well made, a dark Complexion, dark Eyes, and marked with the small Pox; had on when he Escaped a blue Coat with yellow Buttons, a buff Waistcoat with a large grease spot in the middle, corduroy Breeches, worsted Stockings, and stout made half Boots.

Any Person giving information that shall lead to the apprehension of the said GEORGE CROSSLAND alias GEORGE SMITH. or lodge him in any of His Majesty's Gaols, on giving notice to MR. ORRIDGE, Keeper of the Gaol at Oakham, shall receive from the said MR. ORRIDGE a Reward of

Ten Pounds.

OAKHAM GAOL, 29th Dec. 1820.

John Smith, Printer, Oakham.

Money was offered to encourage members of the public to keep a lookout for prisoners on the run...

1818

Murder.

Fifty Guineas
REWARD.

JOSEPH PUGH,

Late of Cow-hill, near Belper, in the County of Derby, Nailor; and

Samuel Cooper and William Cooper,

Late of Belper, in the said County of Derby, Labourers, are Charged (together with others) with the

WILFUL MURDER
OF
WILLIAM ROBINSON,

Game Keeper of FRANCIS HURT, of Alderwasley, in the County of Derby, Esquire, in the night of Wednesday the 22nd instant, or early on the following Morning.

The said JOSEPH PUGH is about 30 years of age (but appears much younger) 6 feet 1 inch high, pitted slightly with the small pox, brown curly hair, stoops with his head, and in walking, hangs forward; he is at this time lame in his right arm, and has the mark of six leeches on his right elbow. He had on when he absconded, a mixed grey coat, and was otherwise shabbily dressed.

The said SAMUEL COOPER is about 30 years of age, 5 feet 6 or 7 inches high, light hair, fresh complexion, grey eyes, the upper teeth rather prominent and observed when he talks, and in conversation speaks slowly: he is broad set and rather knock kneed.

The said WILLIAM COOPER is about 33 years of age, 5 feet 7 or 8 inches high, brown hair, brown complexion, hazle eyes, and of stout make.

Whoever will give information of the Offenders, so that they or any one of them may be apprehended, shall on such apprehension receive the above Reward of

FIFTY GUINEAS,

From Messrs. Lockett, Balguy, and Porter,
OF DERBY, SOLICITORS.

OCTOBER 23d, 1818.

From the Office of G. WILKINS, Queen Street, Derby.

...but the amount offered varied greatly.

consent to preserve my existence by taking away him who gave it; nor could I face the world, or even myself, should I be left the only branch of the family which had been destroyed'.

Hutton said that, 'Love, tenderness, compassion and all the appendages of honour, must have associated in returning this answer. The proposition was then, of course, made to the younger John, who accepted it with an avidity that seemed to tell the court he would hang half the creation, and even his judges, rather than be a sufferer himself.'

So one man decided his future must remain intact by taking the lives of his father and brother. John Crossland Jnr showed no shame, pity or compassion and performed his duty of hangman as though it was second nature. And that, in fact, is what it became. He carved for himself a reputation over many decades as a capable and skilful executioner who enjoyed his work, not only in Derbyshire but around two or three neighbouring counties, until he was an old man.

'So void of feeling for distress, he rejoiced at a murder, because it brought him the prospect of a guinea (£1.10),' said Hutton. 'Perhaps he was the only man in the court who could hear with pleasure a sentence of death. The bodies of the executed were his perquisite; signs of life have been known to return after execution; in which case he prevented the growing existence by violence.'

This is one story of many I have written where the executioner became the victim of greater hate than the victims he was despatching into eternity. This is to a certain extent fair, because not all the perpetrators were people who should be detested or despised. Some were pickpockets, petty thieves, counterfeiters or forgers who met the full force of the court by being sentenced to death.

John Crossland was a hated man and wherever he went he was despised. Even children attacked him in the streets and pelted him with stones or whatever they could find and mothers would try to quieten their crying offspring by mentioning his name. He spent the rest of his sad life without friends, hostile and unfriendly to all.

The Derbyshire biographer ended his commentary on John Crossland and said, 'An historian ... has no choice of subject; faithfulness binds him to accept indiscriminately whatever offers; if he cast the hook, he must take the bite however disgusting. I have caught one of the most despicable of animals in the human form.'

6

FORGER'S GOOD LIFE ENDED IN DEATH

Charles Pleasants lived up to his name. He enjoyed the best that life had to offer and wallowed in the splendour and trappings that money could buy. He dressed in the finest of clothes, had a footman at his beck and call and more often than not was accompanied by a lady of pleasure who provided all the services he required.

Money was no object. It was available whenever his purse needed replenishing and he lost count of the hundreds of pounds he spent. But it meant nothing to him because the young Irishman was a highly skilled forger who never kept a tally of the amount of cash he produced in the short number of years he was a criminal.

Pleasants, a twenty-two-year-old from a good family, was alleged to have confessed that the woman, his companion, 'was his principal ruin', who eventually led to him being sentenced to death. The beginning of the end for this incorrigible young villain was in the early part of 1768.

His parents gave him a good education and hoped that he might become a book-keeper or a clerk. But their young son had other ideas for his future. 'As he grew up his vicious inclinations and unbounded thirsts after pleasure, was not to be restrained by the best of parents. He was of wild and ungovernable disposition as he grew up', wrote the local journalist.

His career in printing and distributing his own skilfully produced money started around two years earlier and probably not long after he arrived in Derbyshire from Ireland. His ability to forge what other people worked hard to earn soon made him rich and he was able to pay off some of his debts with the counterfeit notes he produced, with enough left to bring him a life of contentment and pleasure.

He made several appearances at Derby Quarter Sessions for fraud and was sentenced to seven years' deportation to the far-off shores of Australia. But for some reason that has not become apparent he did not make the trip. However, he did promise that once he had enough money, real or forged, it would 'enable him to leave off that wicked course of life'.

But good intentions, however determined, are not always achieved and it was difficult for young Master Pleasants to surrender the luxurious lifestyle to which he had become accustomed in such a relatively short space of time. He could not give up the elegance of being dressed in pompadour and gold, with a footman in attendance and was unable to cope without a woman as his constant companion day and night, however much he claimed she had been responsible for his ruin.

The good days and pleasures had to come to an end, and on 18 March 1768, the young swindler appeared at Derby Assizes before Sir Richard Alton, a High Court judge. He stood in the dock of a busy, smelly court and was watched by dozens of curious onlookers in the public gallery He was accused of 'falsely making, forging, counterfeiting and publishing as true a Promissory Note for 20 shillings (£1) with intent to defraud Mr John Trott of Buxton'.

Trials in those days were nothing like they are today. Punishment was punitive in the extreme. Few knew anything about human rights and fewer thought there was anything wrong with the sentence of death for such a crime. Hearings were completed in hours with the defendant unable to give evidence on his own behalf. It was believed that if he went into the witness box to give evidence under oath and was convicted, he would be guilty of perjury. It was not until 1894 that the law was changed. Jurors were not sent to a room to reach their verdict in private, but instead stayed where they were to talk among themselves in open court. They reached verdicts in minutes, which made a mockery of whatever legal system was in operation at the time.

Our local journalist wrote for his interested readers that Pleasants was 'convicted on the clearest evidence. He begg'd of the Jury to recommend him to mercy, but the Judge pass'd the fatal Sentence upon him in a very moving Manner, and left him for execution on Friday the 8th day of April, which was three Weeks from the Time of his Condemnation.'

But young Pleasants was temporarily saved from the gallows by an amazing and unexpected piece of last-minute good fortune and circumstances. A King's Messenger arrived from London between eight and nine on the morning that he was to be executed, with a letter granting him some breathing space.

It appears that some friends 'of rank and fortune' in Ireland who had learned of his coming demise, made an urgent appeal to the king for a stay of execution. But his happiness was short-lived and on Monday 25 April, only a few days after his conviction and sentence, a new date was fixed for his hanging on 4 May 1768.

'On the fatal News being carried to him,' wrote our local journalist, 'he was observ'd to tremble very much, tho' he had before made very light of hanging, saying it was no more than dying of an Apoplectic Fit; but being at that Time reminded of the awful change he was soon to make, he said: "I am almost curious to know that change".'

The day before he was due to hang, he received a letter from his mother in Ireland. She was convinced that because of the intervention and involvement of his friends, that he was 'almost certain' to be transported for life instead of being hung. But things were not looking good for the young forger and despite the situation

in which he found himself he was still able boast in public that 'he had done fifty Times more than any other Person who had suffer'd lately for the like Crime'.

When some men face the ultimate penalty, there appears to be a need for them to unburden themselves and cleanse their conscience. Pleasants was no different. On the morning of Monday 25 April 1768, a little before his death warrant was delivered, he decided it was time to make a confession and make a clean breast of things to Mr Simpson, the keeper of Derby jail. The local newspaper had, by some clever means, obtained information about a planned prison escape, of which it felt details should be disclosed to their readers.

It was claimed that he asked for Mr Simpson to be brought to his cell and as the two men huddled together in the confined place, Pleasants warned the keeper of a prison break planned before the last assizes in the city during which time he was to be taken prisoner and 'held fast' while the rest of his family was seized.

Pleasants outlined the desperate escape plan and told Mr Simpson it would be put into operation once he came to lock the prisoners down in the dungeons at night. It was then that some of the 'prisoners were to seize him and hold him fast whilst the others took the Keys from him, lock him in, and secur'd the rest of the Family. This done they were to take the Fire-Arms, rob and rifle the house, then lock up the Prison, and, to prevent anyone getting in to their immediate Assistance.

'It was agreed to break the Key in the Door, and precipitately make their Escape; but this design was happily frustrated; a young Man, who had just been committed for a small Crime, gave early intelligence of their purpose, and Mr Simpson immediately took proper Measures for defeating the same.'

Although this escape attempt failed, it did not put Pleasants off a decision to try another break out because under the sentence of death he felt he had nothing to lose. But sadly for the forger, the planned escape did not materialise 'because of a Confession he employed to procure him Tools, at a Time when he had assur'd himself of success, the Truth of which he has since acknowledg'd.

'Tis certain, from Mr Pleasants' own words, that buoy'd himself up almost to the last with the Expectation of a Reprieve; by these and several other circumstances, it is much to be fear'd he was not so sincere in his Penitence as might be wish'd; but this must be left to the Great Searcher of Hearts, who alone knows the Sincerity of this.'

It is amazing how so often even the toughest of prisoners turn to prayer and hope that some divine intervention will be miraculously forthcoming to ease their passing from one place to another. Pleasants was no exception and shortly after he was condemned to death, he often went to church to attend services and received the Sacraments several times. He listened to sermons that the Revd Mr Searle decided were 'suitable to his melancholy circumstances'.

On the dreaded morning of Wednesday 4 May 1768, the last day he would see the springtime sun rise, Charles Pleasants, a 'middle-siz'd well-looking young Man, about twenty two Years of age', prepared for his life to be taken at the end of a hangman's rope.

The local journalist who had followed the legal rituals since the end of Pleasants' trial, prepared himself once more to share with his readers the last moments of a man's life: 'He seem'd much resigned to his Fate; being put into a cart (dress'd in his Shroud over which was his Great Coat, and an elegant coffin by him) he was carried to the Gallows amidst an inconceivable Number of Spectators, who were much affected at so awful a Sight; at the fatal place he own'd himself guilty to the Fact for which he suffered.

'He forgave his Prosecutors, as well as all Mankind, and after some time spent in prayer, assisted by the Rev Mr Searle, the Cart was drawn away as he was calling on the Lord to have mercy on him; and his last words were: "The Peace of God which passeth all Understanding, keep your Hearts and Minds in the true Knowledge and Love of God and of his Son Jesus Christ our Lord."'

Thousands of people usually watched these public hangings which, for many, were a big day on the social calendar. They travelled into the city from miles around – men, women and children – to watch and cheer the suffering of a young wretch probably none of them knew. His body hung in public for the 'usual time' of two or three hours before it was cut down and placed into the coffin he carried in the cart from the prison to the site of his execution. Several days later he was interred in a 'decent manner'.

It was usual that a few well-chosen words were left as a legacy by the condemned man in the hope others might not follow in his footsteps. Pleasants warned they should, among other things, avoid 'bad Women who had a principal share in his ruin'.

He was described as a young man of lively genius 'and had he emply'd those Talents right which Nature bestow'd upon him, he might have been serviceable to that Country whose Laws declar'd him unfit to live'.

He was allowed to have some Methodists sit with him on his last night and to travel to the gallows without the rope around his neck.

Without a doubt he had a most unusual request granted. He chose one of his fellow prisoners to be his executioner 'to whom he made a handsome present'.

And so another life ended at a time when so many simple crimes attracted the death penalty; setting fire to a hayrick in a farmer's field, for example, or picking someone's pocket, horse or sheep stealing. There were plenty of criminals who passed through the courts like parcels on a conveyor belt. Lawbreakers had little chance. They were fodder for a legal system that needed to put itself in order. But as long as the powerful had control over the weak, there was little chance of anything changing.

7

RUINED BY PATHS OF VICE

Brothers John and Benjamin Jones were cowards. They threatened to kill victims as they carried out a daring trail of armed night-time terror raids on country houses in Derbyshire disguised in white smocks and with their faces blackened.

It was in the early part of 1784, with a third man – who later turned king's evidence to save his own skin – that the trio created a mini crime wave as they broke into occupied or empty homes to help themselves to residents' valuables, silverware and money.

The third man, whose name was never publicly disclosed, fed the authorities all the information that was needed to build a watertight case against the brothers and leave the way open for local constabularies to arrest them.

The death penalty was the sentence for a majority of offences during the fifteenth, sixteenth and seventeenth centuries. Court lists were full as judges on the assize and quarter session circuits in Derbyshire dealt with a mixture of offences from murder, manslaughter, robbery, horse and sheep stealing to bestiality, which left offenders heading for an early death at the end of a rope. Transportation was another favourite for these purveyors of justice in a cruel society that did not give the poor man much of a chance if he committed an offence.

The brothers were born in Ashbourne, and were in their early twenties when they decided to turn to crime on Sunday 1 February 1784. They were hard-working – one was married with three children, a cotton mill framework knitter, and the younger, who was unmarried, worked alongside his brother. Why they decided to steal from others in local communities was never disclosed, but they ventured into the underworld fully aware that if they were caught there was no second chance. Get caught and their necks would crack under their weight as they were suspended from a piece of coarse rope.

The evidence against the brothers came totally from the mouth of the third man and he told how he accompanied them on the first burglary and robbery at the house of an elderly widow living on the Nuns' Green in Derby. It was a cold

February night when the informant said that he and John Jones broke into the old lady's house by smashing their way into the property.

He said, 'They staid a considerable time in the House, searching for Booty and from a Parlour stole and carried away one Silver Tankard, several Table Spoons, eleven Tea Spoons, a silver Butter Boat, four Salt Spoons, a Silver Tobacco Box and various other Goods; also a few guineas (a guinea is now equivalent to £1.10), Shillings (10p) and Halfpence.'

The three villains went together on their next expedition on horseback from where they lived in Derby, and this time made for a house at a place called Culland, a village near Brailsford, breaking into the home of a Mr Wace. They helped themselves to a bureau from the parlour and carried it into an orchard where they examined what was inside but found nothing of value. They departed 'without any plunder tho' in a private Drawer were concealed upwards of 30 shillings (£1.50) which they missed.'

The brothers stood side by side in the dock and listened to the prosecution outline the charges against them one by one, armed only with the 'evidence' provided from the confession of the unnamed third offender. How they selected their victims never became public but they were busy burglars, leaving their wives and children at home late at night and wondering what was going on.

They left for their nocturnal wanderings on horses owned by other people, which they left grazing peacefully in fields. They reached the Turnpike Gate at Spittle Hill at about one in the morning, put their horses in a barn and walked the last mile to Ashbourne and the houses they had chosen to burgle. They broke in by smashing a window and one of them stayed outside to raise the alarm if necessary. Two ladies in the house were woken by the noise of breaking glass.

Both brothers had their faces blackened to disguise their identities and wore white smocks. One lady was immediately threatened with death if she did not tell the brothers where her valuables were hidden. She gave them about £14 from her purse and was then forced downstairs to open the back door so the two of them could escape.

The alarm had been given but the three criminals were lucky enough to escape. It is said that some criminals will return to the scene of their crimes and the brothers were no different. About a week later they returned to Culland and broke into another house where a manservant, hearing the noise of breaking glass, came downstairs armed with a pitchfork to keep the three burglars away. One of the men fired a pistol in the hope of frightening the manservant but he maintained his resolution and, as in the first burglary, they ran off empty-handed.

By now the burglaries were being committed with an increasing regularity and a similar level of violence. Late at night on 14 March 1784, John Jones, the police informant, and another man broke into a grocer's warehouse near St Peter's church in Derby, and helped themselves to a large quantity of tobacco, soap and sugar.

Hours later in the morning of the same day they committed their last burglary and robbery. The brothers, John and Benjamin, and the unnamed informant, broke into a house in what was known as the 'upper end' of St Peter's parish, forcing the

heavily bolted back door with a chisel. Again they had blackened their faces and two of them were disguised in smock frocks.

The burglars, caring little for the safety of their victims and in order to enforce their dangerous determination, carried weapons with them to impress upon the householders that there was a good chance they could get what they wanted.

The informant later told police officers that one of the ladies in the house, 'being alarmed at the noise they made in wrenching open the door, got up and was met on the stairs by the two Jones's who presented pistols and with dreadful threats and imprecations, demanded what money was in the house; but being told there was very little they d-wn'd her and said: "How could the family live without money?", or words to that effect. On this she gave them upwards of thirty-eight pounds in cash, but this was not satisfying them; they declared if she did not show them where the plate was deposited, they would blow her brains out.

One of the Jones's encouraged the other by saying, "Blow her eyes out if she won't hold her noise and direct us where the plate and other valuables are." Upon this she was obliged to comply, and they plundered the house of a silver tankard, a silver watch, coffee pot, pint mug, half pint ditto, silver butter boat, cream jug, spoons &c (et cetera). These were packed up in a cloth with which they made off; but the neighbourhood being alarmed, and now almost day light, were soon pursued; and John Jones who carried the plate, in his hurry fell down a few yards from the house.

A quantity of snow having fallen at the time of the robbery, the two Jones's footsteps were traced, and in a very short time they were taken. On the face of John Jones, especially about the eyes, some of the black remained on when he was taken, notwithstanding he had washed his face, and in his Breeches Pockets were found five guineas, though he had just declared he had no money. This informant was soon afterwards taken on suspicion, and on giving a particular account of this robbery, was admitted evidence.'

The brothers were taken into custody and so ended weeks of terror and fear for ordinary people who thought they were safe in their houses. They went on trial at Derby county hall in front of Judge Ashurst on 3 August 1784. Witnesses gave their evidence and, without being able to bring anything that would help their defence, the case against the brothers ended quickly. The jury had little to consider and a verdict was returned within minutes and 'without hesitation'.

They were doomed and knew their fate instantly. As the black cap was placed on his head by his clerk, the judge passed the mandatory death sentence 'on the two unhappy men'. With a mantra that had become entrenched in a sentencing judge's words, they were advised to use the short time left to them to 'make their Preparation for Eternity'. They were 'exhorted not to entertain any Hopes of Mercy in this World as their behaviour had entirely excluded them from every expectation of that kind'.

In modern day courts the words 'If you can't do the time, don't commit the crime' are often heard. The young brothers were happy to instil terror and fear into the victims as they pursued their criminal reign. But when the law decided

their lives should be made forfeit for their crimes they had committed, their true selves were laid bare.

A local journalist commented on their behaviour and told the readers of the *Derby Evening Telegraph*, 'The two unhappy men were then conveyed back from the hall to the prison; and seemed to take but little notice of their dreadful Situation: John Jones said that as they had stood their trials like men, he hoped they should die like men.'

But brave talk carried little weight and as the time of their execution slowly drew closer it dawned on the brothers that courage and fearlessness was something beyond them. They were, indeed, weak and realised they could not face the hangman when the turnkey locked them in their cell.

John Jones finally realised that his boldness was a sham. Our local reporter wrote with a vast amount of journalistic licence, even though he was unable to get into the brothers' cell. Nevertheless he had the 'skill' to know what was going on behind a locked door and claimed John Jones had 'lost all fortitude and cried bitterly, wrung his hands and seemed agitated to an amazing degree'.

The dreadful truth had finally dawned on the brothers. They were to die and had brought disgrace on their families. The Revd Mr Henry decided to assist them into the next world with the comfort of prayer and stayed with them for some time. He left and they were locked up again, and an hour later the turnkey was told to let them out of their cell for some fresh air.

'But he had no sooner opened, than the two criminals presented an awful sight; which made him retreat and call for help; they were hanging by the neck in their shirts close to the door,' was the newest intelligence our local reporter had discovered.

'A surgeon was at hand, who immediately bled them but to no purpose as they were quite dead; they had tied themselves up to a mortice hole that happened to be in a piece of wood over the door of their cell. It is hoped that the fate of these men maybe a warning to youth to shun those paths of vice, which has brought them to ruin.'

The following day, 5 August 1784, an inquest was held and a coroner's jury returned a verdict of self-murder. The same afternoon the brothers in crime were laid to rest and buried side by side under the gallows.

It is more than 200 years ago that John and Benjamin Jones killed themselves because they could not face the hangman. They hoped that their criminal behaviour and early death might be a lesson to other people. But the centuries have passed and little has changed among certain members of the present-day young community. They have not learned from the misfortunes of others and will either wander into or deliberately enter a life of crime. Fortunately for them, these past punishments are not available to try to teach them a hard lesson. Maybe those handed out by a legal regime two centuries ago might work – but we will never know.

8

LET THE PUNISHMENT FIT THE CRIME

In Gilbert and Sullivan's operetta, *The Mikado*, the chorus of one of their most famous songs, has, over the decades, become part of everyday speech. It is easy to remember and the few words in one particular line, encompass what was barbarically wrong with England's legal system during the past 500 years: 'To let the punishment fit the crime.'

Prisoners became cannon fodder in the nation's courts, where their rights were virtually non-existent. Hanging was pronounced for the most whimsical of crimes and at a time when the poor were poor and the rich had everything, offending was rife as people continually broke the law trying to feed their families.

People who lived in home conditions that were already atrocious were victimised by some of the most appalling and shocking conditions when they were jailed. For most, the death sentence would have been better than spending months or years in sub-human conditions without any rights – even if the powers that be had any idea of what human rights meant.

In the present-day climate, prisoners and the 'barrack-room lawyers' behind bars in prisons all over the land know their rights and trade on them whenever they can. One prisoner won a court's approval to be called 'Mr' by the prison staff. Another was allowed to buy books on homosexual matters and others have taken legal action because their feelings have been hurt, with financial recompense enough to keep them comfortable until they complete their sentences. But these cases are more the exception than the rule.

It is difficult to imagine the unbelievable cruelty that was once part of the everyday life of prisoners. Derby had its fair share of horror in its prison and many waited for the day when it would their turn to get ready to meet their Maker.

Let's start on 1 August 1556. The case of Joan Waste (Chapter 4) has become an international example of how cruel people can be. She was twenty-two years old and born blind. She believed the Sacrament was only a memorial or representation of the body of Christ and the elements were just bread and wine.

Being a Full and True Account of a barbarous Murder and
Robbery committed upon the Body of Mr. *Hooper* and his
Wife, and th ir Servant-Maid, laſt Night about Ten a Clock,
at *Hornſey-Cave,* by Four Disbanded Soldiers.
With the manner of their being Apprehended at Highgate,
and commitment this Morning by Sir *Edward Gould to Newgate*

M Urder is one of the moſt heinous Crimes, of which a Man can be guilty, and
moſt juſtly requires Blood for Blood; and altho' a Murderer too make no
other Atonement but the forfeiture of his own Life, yet to obtain, towards and
villainous are the wicked Minds of ſome Perſons, that not of Hatred, Revenge, Co
vetouſneſs, or ſome other notorious Diſpoſition, they care not what kind of ſin, so
derge, for the perpetration of Murder ; for which Cain was curſt'd and made a
Vagabond up and down in the Earth, and accordingly as the ſeverity of our Laws
againſt this Crime, yet the Cruelty of ſome Men are ſo inhuman, that they imbrue
both their hands in the Blood of their Fellow Creatures, which is a ſin of the higheſt
Degree againſt God, as being a defacing of his holy Image. Beſides the notorious
Sin of Theft, which the aforeſaid barbarous Villains committed, add much more to
their Guilt. The terrible Relation whereof take as follows.

THIS honeſt, but unfortunate Man, kept the uppermoſt Cave in *Hor-
ſey Wood*, where by his Induſtry he had gain'd a pretty competency of ſome
of the Riches of this World, having a great Trade, eſpecially on Sundays,
when he ſeldom took leſs than Twenty Pounds, which the abſoluteſt Villains
undoubtedly were ſenſible of ; for laſt Night about Ten a Clock they came
up to the Cave, and the Door being ſhut, one of them wrapt at it, when
Mr. *Hooper* asking who was there, the Fellow anſwer'd, a poor Disbanded
Soldier, almoſt ſtarv'd for want of a little Victuals and Drink ; upon which
Mr. *Hooper* open'd Door, and his poor Carty a little and he would Before
him plentifully, and accordingly brought out the remains of a Gammon of
Bacon, ſome Buttock Beef, Bread, and a full Pot of good Beer, ſaying, here
my Lad, this will refreſh thee ; and giving him his Hat full of Meat, put the
Pot into his Hand and bid him drink it off ; which he was about, when the
other three Ruffians inſtantly leap'd upon Mr. *Hooper*, and taking hold of
him ſaid, Dam ye, Sir, do you give him all the Drink, we are all of a Com-
pany and ought to have ſhare. This was a great ſurprize to Mr. *Hooper*,
however he did not ſhow himſelf angry, but ſaid, Gentlemen, I thought your
Friend to be alone, I did not ſee you before, or I would have brought every
one a Pot, which you are now welcome to, and I'll fetch you ; and going
down Stairs in order thereto, they follow'd him, and after they had drunk
round, one of them Collar'd Mr. *Hooper*, and demanded his Money, but he
broke the Villains hold and got him under his Feet, but two more falling on
him, with much ado they overcome him, and getting him down, much be-
barouſly ſtampt on him till he was almoſt dead ; In the mean time his Wife
and Maid were bravely fighting the other two Rogues, but being at laſt over-
come, they ſhriek'd out as loud as poſſible, in hopes of alarming the Folks
of the other Cave, but to no purpoſe ; and to prevent their further crying
out, one of the inhumane Rogues ſtabb'd them both with a Bayonet, ſo that they
inſtantly died. Then the Rogues rifled all their Pockets, and afterwards
ſearch'd the Cave all over for Booty ; and having got a gold Watch of Mrs.
Hooper's, and his ſilver one, with 30 l. in Money, a Silver Tankard, and other
pieces of Plate, &c. they went off, but they firſt drank up a Quart of Brandy
which they found, and ſate upon the dead Corps all the time, but Mr. *Hooper*
being not then quite Dead, one of the Rogues ſtamp'd again on his Breaſt.

All which a Boy of Mr. *Hooper*'s ſaw, who had hid himſelf in a convenient Place
in the Cave, and after they were gone acquainted the other Cave People with
it, and that they were gone toward Highgate ; whereupon purſuit was made,
and they were apprehended at the Black Bull at Highgate, being all drunk and
aſleep ; and being carry'd before Sir *Edward Gould*, and the laſt proving the
Fact upon them, Sir *Edward* committed them all this Morning to Newgate.

Wherefore that we may all avoid this horrid Crime, let the Word of the
Royal Pſalmes be ever in your Mouths, *From Blood Guiltineſs, O Lord deliver
us,* &c. Printed by J. Smith, in Fetter-ſtreet, 1712.

Full details of cases were often published by private companies for the benefit of people
unable to get to court.

She was accused before the bishop of the diocese of heresy and was urged to renounce her beliefs. But she persisted in what she felt was right and was convicted and condemned to be burned at the stake. What a shocking and horrifying way to die, chained to a stake in Windmill Pit on the Burton Road, in the middle of fierce fire while still alive and slowly incinerated.

Three Roman Catholic priests were tortured then butchered on 24 July 1588 because of their beliefs. They were hanged in Derby, their bodies were drawn and quartered and what remained was allowed be displayed on the town's St Mary's Bridge as rich pickings for the birds.

In 1609, three sisters were hung for alleged witchcraft. But on 14 March 1665, a woman who could not speak suffered the worst form of death, apart from being buried alive. She was sentenced to be pressed to death because a court said she refused to plead to an offence and remained mute.

She was warned three times of the fate she would suffer if she maintained her 'obstinate silence'. She was sentenced to the Judgement of Penance and taken back to the local jail. There she was taken to a dark dungeon into which light could not enter, laid naked on the floor with only a loincloth around the low half of her body for decency.

On the first day of her punishment all she was allowed to eat were 'three morsels of the coarsest bread'. There was no food on the second day only 'three draughts of stagnant water from the pool nearest the prison door. On the third day again three morsels of bread as before and such bread and water alternately from day to day until you die.'

What happened from day one must have been one of the most barbaric forms of punishment man's fertile brain could have devised. As she lay in the dark with men and sound around her, iron weights were placed on her body. The longer she remained quiet the heavier the weight until it reached the stage where her body was so badly compressed that she eventually suffocated.

As the years went by and one century moved into another, people were hung for cattle and horse stealing, picking pockets, housebreaking, highway robbery and counterfeiting. One man who was executed on 28 August 1740 for making his own money, was buried at Sutton-on-the-Hill. He had the added indignity of his body being 'snatched' from his grave the following day – no doubt for medical studies.

One poor soul named Thomas Hulley was the victim of double jeopardy. He was sentenced months or years earlier and transported to Australia. But the poor man was hung sometime in 1757 for having the courage to return home.

In 1776, the last case of gibbeting in Derbyshire was recorded when Matthew Cocklane was convicted for murder. A blacksmith visited him in his cell to take measurements for a steel frame that would fit over Cocklane's dead body. Soon after his execution, he was taken down and fitted fully dressed into the frame, which was then covered with pitch. The whole contraption was hung in chains from a tree until his corpse had rotted and formed a food feast for the birds, who picked his remains.

John Shaw was hanged on 2 August 1782 for breaking out of jail. There was no end to the novel ways of disposing of someone after they died at the end of a rope. On 29 March 1790, Thomas Grundy was hung for murdering his brother, then his body was taken down and publicly dissected by a local surgeon for the benefit of medical research. Most of the spectators watching were medical students.

Some black humour occurred at the time of a public execution, particularly in the case of John Brown, Thomas Jackson, George Booth and John King. They were facing the drop on 15 August 1817 for arson at North Wingfield, when it began to rain.

The *Derby Mercury* reported, 'As every fact which may tend to illustrate the principles of human action deserves notice, it is worth observing that a heavy shower happening whilst the doomed men were singing a hymn, two of them deliberately retreated to the shelter of an umbrella which was expanded on the drop and a third placed himself undercover of a doorway. The inconvenience of being wet was felt and avoided by men who knew they had not five minutes longer to live.'

In 1822, Hannah Halley of Brook Street, Derby, was the last woman hanged in the city. She was executed for the murder of her baby child. The last public hanging in the city was on 11 April 1862 when Richard Thorley died for the murder of Eliza Morrow.

The executions carried on until the last one in Derby when William Slack was hanged on 16 July 1907.

Harsh sentences no doubt but they did not have the required effect – to reduce crime. People by their very nature carried on committing offences hoping to beat the system, but the legal wheel kept turning slowly and caught them one by one. Since the beginning of time when Adam and Eve were told to keep their hands off the apple and when Cain slew Abel, people have never learned. If there is a law someone will break it, whether it applies to simple theft or murder.

Crime has got worse, of that there is no doubt, but the difference in today's society is that criminals will never again have to suffer the humiliation, outrage and abuse inflicted upon their predecessors. Bringing back the birch or the stocks may help to bring sense to some of today's villains but then we are entering the "human rights" arena once again.

> **My object all sublime*
> *I shall achieve in time –*
> *To let the punishment fit the crime –*
> *The punishment fit the crime;*
> *And make each prisoner pent*
> *Unwillingly represent*
> *A source of innocent merriment!*
> *Of innocent merriment!*

9

A CRUEL MAN WITHOUT LOVE

Benjamin Hudson was a problem child. He caused his caring mother and father grief and over the years showed little interest in school, work or the church. He could just about read and write and spent his working life as a miner not too far from his home at Handley, about five miles from Derbyshire town of Chesterfield.

His only claim to fifteen minutes of fame came when he killed his young wife, Eliza and made a judge cry while he was being sentenced to death at Derby Assizes on Monday 14 July 1873. I covered more murder trials than I care to remember while working as a journalist, and not once did I see a judge overcome by emotion of the slightest degree. Admittedly, hanging was outlawed in the 1960s, but still judges did not let themselves be deterred by the crime for which they were sentencing a convicted man.

Hudson was born in 1849, was twenty-four years old when he died and had fathered four children. He was a seasoned and skilled poacher and had more consideration and love for the dogs he bought than the children he fathered. The treatment of his wife was described by locals as 'brutal in the extreme'. But what people thought was the least of his worries and they did little to bother him even though he was labelled as 'cruel without remorse, sensual without passion, a husband without affection and a father without feeling'.

When the jury returned its guilty verdict with a recommendation for mercy, there was 'perfect stillness – not a rustle, not a breath'. The black cap was placed on the judge's head and he asked Hudson if he had anything to say before sentence of death was passed. Hudson did not appear to understand the situation in which he found himself and looked intently at Mr Justice Honyman. He made no reply and in the 'painful silence' of the court the judge was 'solemn and impressive and the sentence fearful to hear'.

A reporter from the *Derby and Derbyshire Gazette*, who covered the trial, wrote:

The judge was affected to tears, and frequently sobbed as he was passing sentence. The prisoner received the sentence with stolid equanimity; he stood like a marble statue without the motion of a single nerve. After the passing of the sentence the prisoner gazed stupidly about him for an instant and was then led out of the court and conveyed to the county gaol.

Journalists in the 1700s, 1800s and early 1900s, seemed to be able to get away with a lot of comments in their reporting of cases. At the trial of Hudson, the unnamed reporter took advantage of his position in local society and referred in a matter-of-fact manner to the 'impassioned and pathetic' address made to the jurors by the defence barrister when he urged them to reduce the charge from murder to manslaughter.

For a court reporter today, a respected reputation earned over many years could be sorely damaged if he was of a mind to make comments like that to other barristers let alone write copy with such little respect for the lawyer. I have met barristers who have passed their law exams with high marks but who I found pathetic and with little skill; however, it would have been more than my reputation was worth to pass such comments.

But what of the circumstances surrounding the death of Benjamin Hudson's wife? They were cousins and were married for about two or three years. He was a bully and a thug and throughout their short-lived, loveless union he quarrelled constantly with the young woman, making her miserable life even more wretched and pitiable.

They had a child before they were married and as they trod the first steps as a married couple the unfortunate, weary woman began to realise the deplorable problems that life had in store for her. She lived in fear of violence. There were constant beatings that became such a regular event that on two occasions she had her husband bound over to keep the peace. He was also jailed for three months for breaching one of the orders, but being deprived of his liberty seemed to make little difference.

He loved killing, and according to remarks made by his grandmother to a local journalist, 'he was never so happy as when he was taking life.' Birds and rabbits were his special delight. His parents could not cope with his behaviour and tried to bring about some change in his character. They decided he might learn something if he went to the Handley Methodist chapel and Sunday school. It was a waste of time. As he became more unmanageable he preferred wandering around the woods near the family home rather that spending time listening and learning from the local preacher. As the years went by, his behaviour moulded his character into one that made him take no notice of pleas from others to change his ways. He had taken on his cousin as a wife, but by then his character had become unstable and disturbed, so much so that his violent episodes became more frequent and after their wedding the luckless woman suffered frequent beatings, which became regular episodes and a terrifying part of her daily life.

On 24 April 1873, his rage went out of control and he beat his wife to death with a hedge stake late in the evening as she was walking home and 'left her perfectly

dead' on the footpath with seven serious injuries to her face and head. He clearly knew what he had done and within minutes was back in the village of Handley where he sought out an uncle and confessed to him that he had killed Eliza. He told his relative that he had 'knocked her skull in' and with careless abandon left his uncle's house, ran down the garden, jumped over a wall and started to sing a comic song.

Minutes later he gave himself up to the police and shortly afterwards appeared before Chesterfield magistrates charged with murder and was remanded in custody to the county jail at Derby to await his trial at the summer assizes.

The couple had separated during the Easter week shortly before her death and Eliza moved into her father's house. On the day she died she had spent the day cleaning out the house she had shared with her husband and children. Later she went to a neighbour's house nearby to carry out some work and her husband spent the day outside the property being abusive and making threats to the young mother.

As his anger reached a fever pitch around seven in the evening, he went away for a drink at the George Inn at Lightwood. He left about an hour later. His wife bade her neighbour goodnight and left their house to walk home to where she was staying with her father. Sadly, she walked towards her unstable husband with only minutes of her life left.

There weren't any witnesses to the murder, although one woman met Eliza and walked part of the way with her. At the same time, Hudson was seen by a man walking towards Lightwood. Shortly afterwards the poor woman was beaten to death. There was only a short police investigation because Hudson confessed to the savage murder of his wife. Apart from statements from the couple who saw Hudson and wife, the only other evidence was from a doctor who carried out a post-mortem examination. Two and a half months later on Monday 14 July 1873 he appeared in court where his future would be in the hands of twelve jurors.

In a court crowded with curious citizens who took their places in the public gallery, Hudson was arraigned by the clerk to the court and after the indictment was read to him he surprised everyone by pleading guilty. His counsel, a Mr Waddy, asked for the indictment to be put again because as he told the judge Hudson did not know the difference between murder and manslaughter.

However, Hudson admitted he caused his young wife's death but did not mean when he pleaded guilty that he had 'wilfully and of malice aforethought' done away with her. There was little evidence to call and as was so often the case in capital offence trials, the prosecution's case was soon over. There was no evidence to call on behalf of Hudson and he was not allowed to go into the witness box to defend himself.

Parliament had decided years earlier that if a defendant gave evidence under oath and was then convicted he could be charged with perjury. A strange approach under a legal system that gave a defendant no rights to explain to a jury what happened. It was a one-sided to say the least and it was another quarter of a century in 1898 before the law was changed and a defendant became competent to

give evidence from the witness box under oath like all those who had gone into the witness box before him.

By 12 August 1898, the Criminal Evidence Act entered the statutes book and from then until the present day a defendant has the same rights as all other people who came to court as witnesses. The Act declared, 'Every person charged with an offence and the wife or husband as the case may be of the person charged, shall be a competent witness for the defence at every stage of the proceedings whether the person so charged is charged solely or jointly with any other person.'

The defendant was not compelled to give evidence but he had the support of the law to decide for himself whether he wanted to go into the witness box; he had the absolute and non-negotiable right to make that decision. That was the overwhelming point of the legislation. If he decided he did not want to give evidence the prosecution was not allowed to make any comment.

Even today, a defendant is not forced to give evidence when the defence case starts. The prosecution brings the case to court and must prove his guilt beyond a reasonable doubt and it is not for the defendant to prove his innocence. All he needs to say when his trial starts is 'not guilty'.

However, there is now one caveat. Nothing is perfect. If a defendant decides during his twenty-first-century trial that he does not want to give evidence, then a judge in his summing up may point this out to the jurors and let them reach their own conclusions. This applies when a person is tried for any offence.

Local newspapers had a lot to say for themselves in the eighteenth and nineteenth centuries and the *Derby and Derbyshire Evening Telegraph* was no exception. In a Special Execution Edition of the newspaper on Monday 4 August 1973, the pen of a local journalist was let loose and he wrote:

> The verdict of the jury, we may safely say, met with the entire approval of the public.
>
> The result of the trial showed – as we believed it would show – that the unhappy Handley collier is an ignorant, passionate man, goaded by an abandoned woman to the committal of unnatural and inexcusable crime. The verdict, therefore, was the vindication of social law in the interests of order, and for the safety of the community.

> It claims that the genius of our law protects the poor and the base as absolutely as the rich and the good. Society has taught its awful, inexorable lesson to the dissolute, the desperate, the reckless and the passionate. The most tender-hearted humanitarian – and we are by no means the champions of capital punishment – will admit that Benjamin Hudson has fairly earned his terrible fate.

The newspaper was preaching to the converted and had an audience that would support without question the harsh words that were written. The newspaper stated:

If any murderers are to hang at all, Benjamin Hudson should swing. The deed he did was bloody, treacherous and cruel; it was planned for the basest motives and carried out under circumstances of revolting brutality.

The story of the murder has few parallels in the annals of crime. But it is a waste of words to dwell further on his turpitude. He has given the truth; he has admitted his crime, and the justice of his sentence and the guilty man has been dismissed from this world.

We punish not for vengeance, but for protection; and when the law hangs the ruffian who has beaten the partner of his life to death in a paroxysm of drunken jealousy, it acts for the safety of the community, and the warning of the reckless.

Let us for a moment board a time machine and return to 4 August 1873 and bring back with us the reporter who penned those words and let him view the violence and murder of the twentieth and twenty-first centuries. He would hear of murders so barbaric in the extreme that he might wonder if he was hearing the truth. Cases where victims are butchered and hacked into numerous pieces; where the elderly are bludgeoned to death in their own homes; how children are snatched from their families to die horrifying deaths at the hands of frenzied psychopathic paedophiles and how serial killers prowl the streets for victims and dispose of bodies around the country. We might not punish for vengeance but when those hated criminals are sent to prison the law of the jungle rules and eye-for-an-eye retribution takes over.

As for Hudson, he would leave home for days on end and return to his family to feed his lust for violence and beat his wife 'and discolour her eyes by way of welcome. His brutality became unbearable', wrote our local scribe. Hudson was separated from his wife for only six weeks before he killed her. The reporter visited Handley but could find no one, except licensees, who had a good word so say about him.

'Eliza Hudson, we fear was another of the hapless victims immolated at the shrine of Bacchus,' he wrote. 'Publicans informed us with earnestness that "Ben was not a bad fellah arter all, he was perhaps a little bit too fond of his beer. He was generous to a fault". Several attempts were made to get up a petition to Mr Bruce, the Home Secretary, praying for a commutation of the dread sentence, but not a single signature to that petition could be obtained.'

On the day one of Hudson's four children died, he spent the time dancing and singing and swearing in the house and ignored his wife's impassioned pleas to change his behaviour and show some respect for the little one who had passed on. He refused to attend the child's funeral and friends even bought him black clothes for the occasion. While his wife stood at the youngster's grave bidding her child farewell, her husband was enjoying himself at his favourite pastime – hunting for ferrets in nearby Handley Wood.

It beggars belief that Hudson could behave the way he did but it was only much later, as he waited for his early morning appointment with the hangman, that he showed the first sign of any remorse for the death of his wife. At the same time he asked to see his children who were brought to his condemned cell by his father-in-law – the man he refused to meet.

We all think of death because it is a natural part of life and the older one becomes the more often a person's mortality is put into perspective. It is a hope we all cherish that death will be painless and arrive while we sleep. But for Hudson, he knew exactly when the Grim Reaper would appear.

From the time of his sentencing before the packed court at Derby Assizes, Hudson on Monday 14 July 1873 he knew that at 8 a.m. on Monday 4 August of the same year he would be unceremoniously hung inside the local prison – the first private execution. No more would there be hordes of people leaving their homes from villages and towns in the surrounding countryside for the big event of a public hanging – something that had been a major social event in the county for 200 or more years.

Only a chosen few would see Hudson dangling and twitching as he fell through the trapdoor and hear his neck crack in the early morning stillness as the hangman's rope brought the drop of his body to a sudden stop.

Our local journalist recorded for the future all that happened in court and on the day of Hudson's execution decided that going to see a man hang could be described as 'one of the privileges accorded to the press and one of the amenities of journalism'. A thought-provoking message to the ordinary man and woman in the street, no doubt, and, in the same breath, he explained that the duties of a reporter were as 'varied as they are important'. He wrote:

To describe the execution of a convicted murderer is one of the least pleasant of a reporter's varied duties. And that was our painful lot this morning. The execution of Benjamin Hudson, which took place on this dull, damp August Monday morning, differed from all executions that have hitherto been held in Derby. It was the first private execution held in our town.

Words are too weak to adequately describe the blessings ensuing from the innovation. Those people who have witnessed anyone of the public executions that used to take place in front of the county prison, have witnessed a spectacle which time – 'that great obliviator' – cannot readily obliterate.

There could not be a sight so inconceivably awful as the wickedness and levity of the immense crowd collected at such executions. A spectacle more demoralising, more contaminating, more corrupting, could be imagined by no man, and could be presented in no heathen land under the sun. The screeching, laughing, yelling and howling made one's blood run cold.

And how could we describe the thieves, the low prostitutes, the ruffians of every description, the vagabonds of every kind, who flocked onto the ground with every variety of offensive and foul behaviour.

He said that when the sun rose brightly on the day of the last public execution 'it gilded thousands of upturned faces, so inexpressibly odious in their brutal mirth or blatant callousness that one had cause to feel ashamed ... and to shrink from himself as fashioned in the image of the devil. It is no longer in the power of the public to witness such a degrading sight.'

There are people among us now who call for the return of the death penalty. The possibility that they might hang never crossed the minds of people when they were committing a variety of crimes that carried the death penalty during many centuries of our history. Would it stop people now if they knew they would hang for murder? I doubt it. The only possibility that could save them from having a noose placed around their necks would be a jury loathe to convict and take responsibility for a man or woman losing their life.

But what of Benjamin Hudson? He had just over three weeks to think about his limited future. He knew the date on which he was due to die and realised that nothing could stop it happening. How does a person cope, knowing that there are only days of their life left and that nothing can stop it from happening? It is one thing to know that, for the vast majority of us, death will appear when we least expect it, but to be in a condemned cell, knowing he would die at a specific time on a designated day must have been difficult for Hudson to come to terms with.

Hudson never talked about the murder of his wife and when asked if he had ever been sorry for causing her death, he told one questioner that he did from the moment he committed 'the fearful deed'. He never expected his sentence to be commuted to life in prison even though the jury had recommended mercy.

Two days before his execution, sixteen of his friends visited him. He spoke little to them but one observer declared that the sight of two of his older children 'visibly affected him'. His mother always maintained the strong belief that he would be reprieved. Representatives of the press were banned from attending the condemned sermon preached by the prison chaplain, the Revd H. Moore, who carried out more than his fair share of preparing prisoners for a possible afterlife.

Our reporter from the *Derby and Derbyshire Gazette* had his own feelings and expressed them without reservation in the Special Execution Edition of the newspaper. He wrote:

> Imagine what must be the feelings of the unhappy wretch who is compelled to listen to the noise of the workmen erecting the hideous scaffold on which he is to expiate his crime.
>
> Think of the torture caused by hearing the nails being driven one by one into the apology for a coffin which is to enshrine his own disfigured corpse. But of all the barbarous customs which are inflicted upon the condemned, none can cause more anguish to the murderer than to be enforced to listen to what is termed 'The Condemned Sermon'.

Nowadays, wayward people who complain when they are sentenced to a term of imprisonment are told 'if you can't do the time, don't commit the crime'. The same

must apply to hundreds in Hudson's position. They know what will happen so keep out of trouble.

4 August 1873 arrived with a heavy downpour of rain. The gallows was patiently waiting as Hudson was made ready by the prison staff ten minutes before he was due to be hung. A prison bell tolled to mark the few moments left in his life. The sight of the hangman, Marwood, from Lincolnshire, coming into his cell to pinion his arms behind his back was the final seal on the life of Benjamin Hudson. He did not speak or show any sign of fear or dread but resigned himself to his fate.

Marwood, who had taken over from the retired Calcraft as hangman, 'was a harmless looking individual – as much like a clergyman as a hangman'. Hudson was only the second man he had hung and observers noticed that he went about his work with a 'cool deliberation'. The prison bell continued its mournful tolling marking off the remaining minutes of Hudson's life as he stepped onto the gallows steps, carrying a bunch of flowers. The noose was put over his head and Hudson's face was covered with a cap. The hangman moved away to pull a lever and as the prison clock declared the time as eight o'clock, the trapdoor on which Hudson was standing gave way. The wife killer becomes yet another statistic during a barbaric time of our country's history, when hanging was more the rule than the exception.

Our observant reporter, who was never short of dramatic adjectives, wrote:

> The whole of the hideous, sickening, ghastly, wicked scene passes before the eyes again. It is an awful one to see and very hard and painful to describe. Contact with death even in its least terrible shape, is solemn and appalling. How much more awful is it to reflect on death – coming not to the dying -- but to a man in full health and vigour, in the flower of youth, with all his faculties and perceptions as acute and as perfect as your own, but cut off with the hand of death imprinted upon him as indelibly as if mortal disease had wasted his frame to a shadow and corruption had already begun?

Benjamin Hudson had parents who cared for him and his future and did their best to educate him and give him opportunities. But he pushed aside all their help and as his life of less than a quarter of a century developed, he became a psychopathic bully who cared little for his children and even less for his wife.

He killed her and paid with his life. He could not complain.

SEEDS ON STONY GROUND

Diversity in business is a commendable attitude to meet changing economic situations. But it is somewhat of a risk when it involves highway robbery, horse stealing, poaching and a bit of housebreaking thrown in for good measure.

The law takes exception to those who pride themselves in testing the system, and Thomas Hopkinson was a constant thorn in the side of society and a well-known local villain.

What made the situation worse was his age. Young Thomas was only twenty years old, but he had a record that would have been the envy of any hard-bitten criminal. He was born in Ashover, Derbyshire, in 1799 and, by the time he was fourteen, was on the way to becoming an experienced entrepreneur in the field of crime. He would try his hand at anything and, according to a local scribe, 'formed an intercourse with abandoned companions, and commenced that profligate career which brought him to an untimely end'.

He and four friends – Thomas Jackson Jnr, John King, John Brown and Gordon Booth – decided for fun to set fire to some stacks of hay and corn in a farmyard owned by local landowner, Colonel Halton.

They were all caught and committed to the Derby Assizes to fight for their lives as their offence carried the death penalty. Hopkinson realised the situation could be disastrous for his own future and to save his own skin became a poacher-turned-gamekeeper and gave evidence against his four co-accused.

They were convicted and hung but as the local scribe told the populace 'their dreadful fate afforded no salutary warning to Hopkinson'. Now, with his life spared, he left the court ready to continue with his criminal activities and with no thought at all for his future. Crime was in his blood and that was it. That was what fate had decreed and there was no way he could be turned in another direction.

One offence led to another and each time the crime became worse. But he was not bothered. It encouraged him and the excitement was in his blood to spur him on to commit a string of offences. 'His life, though a comparatively short

one, has been marked by an incredible number of offences', wrote our local scribe.

'Of these he made a confession during his confinement in the house of correction at Chesterfield, and they are more than sufficient top shew [sic] that his whole time was spent in the perpetration of almost every species of vice.

The petty pilfering in which he first engaged, gradually led on to bolder offences; his mind became so familiarized with guilt that he seemed scarcely sensible of its depravity; and thus in the natural progress of iniquity, he has led on until he was driven away in his wickedness.' What a way with words so long ago!

Thomas Hopkinson was easily led and got into the wrong company, which was nothing unusual in the generations that followed. He refused to read his Bible, stayed away from church and what he had learned from that environment was ignored. He went the wrong way rapidly to an early grave.

'His first transgressions may with great justice be referred to the wicked company of Thomas Jackson who was his constant associate', wrote our local scribe, whose faithful opinion of such a wayward young man was read by many people on the day Hopkinson died. 'After this intimacy had been formed, every moral feeling and every religious consideration were abandoned. The seeds of instruction which had been sown in his infant mind, were choked and became unfruitful.'

By now his four companions had been dead for about two years, but to their memories Hopkinson became a lone ranger and continued far and wide his criminal occupation – poaching, robbing, stealing horses and sheep, housebreaking and highway robbery; all carried the death penalty.

In young Hopkinson's day and for generations before and after him, the legal authority's idea of justice was more of a joke than something that could be prescribed to try to reduce crime. Murder and the theft of a few pennies carried the same penalty. The lawmakers in Parliament could not see the glaring and obvious difference between the crimes.

A criminal had no chance if caught. Most of the time they paid for their crimes at the end of a rope in front of baying crowds of spectators, who loved nothing better than seeing one of their own having his neck stretched to breaking point.

He was a busy villain at night time, spending the day 'in that kind of idleness which is ever the fruitful source of fresh crimes, or in dissipating in profligate excesses the money acquired by his nefarious practices'.

When the five friends were together, they terrified local people but when he was on his own, long after they had died, Hopkinson was just as determined to intimidate and put the fear of God into his victims. Such was the case on his final enterprise. This time he was with a companion and they decided to commit highway robbery on the Turn Pike Road near Dronfield not far from Derby, in March 1819. They stopped the unfortunate traveller, William Bucknall, and 'putting him in bodily fear' they helped themselves to his purse which contained twelve shillings and sixpence, then took off into the night.

But somehow they were caught. Hopkinson was sentenced to death at the end of March but what happened to his companion is a mystery, although it is almost

certain that he, too, must have been given to the hangman. Hopkinson apparently showed no concern at what was facing him. However, he was more concerned for a young woman he saw in Derby Prison chapel, who was also facing execution.

Our scribe recorded that he was not capable of 'deep reflection and seldom seemed sufficiently concerned with the awful situation in which he himself was placed'.

And so Thomas Hopkinson, only twenty years old, prepared to meet his Maker. On 2 April 1819 he was taken from the condemned cell where he had spent only a few days after his conviction and, accompanied by the prison governor, the chaplain and a number of warders, was placed into a cart and driven in the direction of the gallows.

A crowd was waiting for him as the cart was placed under the gallows and the executioner placed a noose around his neck. The signal was given. Someone slapped the horse pulling the cart and the animal leapt forward, leaving his cargo hanging from the end of a rope.

11

WHAT HAPPENED TO
THE OTHER WIVES?

A shrill, prolonged, piercing scream of agony shattered the peace of the night, as it settled like a blanket over the Derbyshire village of Bugsworth. Three young girls on their way home from school watched in horror as they turned towards the sound and from the lighted cabin of a canal boat saw the silhouette of a man standing over a wife he had beaten senseless with a metal bar.

The fact that sixty-six-year-old boatman John Cotton was eventually hung for the murder of his wife, Hannah, thirty years his junior, was not the end of the story. Cotton was alleged to have made a disturbing confession as he waited for the hangman to take his life.

John Cotton was a man without friends, of a highly volatile and violent disposition and seemed to express his anger towards anyone who came within his range. He was a jealous husband and seethed with frustration if he ever saw his wife talking to other men.

On the night of her death, 26 October 1898, it was claimed they were drunk after leaving the Rose and Crown public house, but witnesses – particularly the licensee of the Rose and Crown and his wife, who both testified at the trial – said that Cotton had only one glass of rum and his thirty-six-year-old wife was satisfied with tea.

John Cotton was born in 1827 at Penkridge, Staffordshire, around four miles from the county town of Stafford. He was married to Elizabeth, also born in 1827 at Sedgley, now part of the West Midlands. The couple lived on a canal boat with their three children – Maria, born in 1866 and described as a boat-girl, and their sons, Thomas, who arrived in 1870, and John who was born in 1871. They were both described as scholars.

Sometime later, Elizabeth died. It was thought the children went their own way and Cotton later married for the second time and moved to Bugsworth and set up home in a boat on the Upper Peak Forest Canal. His second wife died but details were not disclosed. Cotton eventually met and married Hannah and they, too, lived on the canal boat.

Cotton was prone to violent outbursts of psychopathic temper and, as with all bullies, it ultimately meant that his wife could expect a beating. When he appeared for trial at Derby Assizes on Wednesday 30 November 1898, the court, as usual, was packed primarily with people who enjoyed the gruesome.

They were not disappointed when Mr J. H. Etherington Smith opened the case for the prosecution in front of Mr Justice Mathew and an attentive jury. Like the great majority of cases publicised, details of the evidence were usually only available through the diligence of local newspaper journalists, whose skill at reporting trials without the use of shorthand has to be admired.

He described how three schoolgirls heard Hannah's screams as she was attacked and they went to the nearby Rose and Crown for help. Mr Etherington Smith told the jury that when they arrived, 'the prisoner was seen standing over the deceased with a poker in his hand and assaulting her with it. She moaned and he mocked her, threatening that if she did not cease crying he would throw her into the water. She was rescued and medically attended to. However, the base of her skull being fractured her condition was from the first was hopeless and death ensued shortly afterwards.'

Jurors showed their horror and people in the public gallery gasped when the prosecution claimed Cotton was heard to tell the wife of the licensee of the Rose and Crown that 'he would serve her the same if she said anything about it'.

Schoolgirl Elizabeth Copeland was the first prosecution witness to give evidence and she remained calm and self-composed as she answered questions, relating to the court what she had seen while she was on her was home. She said she was walking home from school with friends when she heard the sound of screaming coming from the direction of the boat moored in the canal basin.

She said the cabin door was open and she saw Cotton standing over Hannah with a poker in his raised hand. She went for help and returned with other people. A Mr Lawrance [sic], defending Cotton, had a difficult job on his hands and cross-examined the three girls who corroborated each other's evidence closely.

James Carrington, a local farmer and land owner in Bugsworth, supported the girls' evidence and said he was passing by when he saw the murder being committed. He said his interest was naturally drawn to the noise emanating from the canal boat and although he could not see Hannah he saw that Cotton had a poker in his hand raised as if to strike someone. He assumed that the unfortunate wife was lying unconscious on the floor.

He said he asked Cotton what he was doing and he replied, 'Nothing.' Mr Carrington said he heard Cotton say he had had two wives 'and meant to have another as he was tired of the deceased'.

As Hannah Cotton lay defenceless, senseless and moaning on the floor, Carrington claimed, her husband mocked her and called out to him to 'hit her with the coal hammer or else hand it to him and let him do it'. Mr Carrington also gave the alarm and several people from the pub went to the canal boat to rescue the battered Mrs Cotton and take her to a place of safety so that she could be given assistance.

Mr Carrington said that after Cotton was taken away he went into the cabin of the boat and found a poker covered with blood and hair. He put it away safely so that it could later be handed to a policeman.

He was asked by Mr Lawrance, the highly skilled son of a High Court judge, why it had taken so much time for him to intervene and he replied he 'did not do so because he was afraid the prisoner might assault him'. In present-day parlance it meant he would sooner be a live coward than a dead hero.

There was laughter in the court room at Mr Carrington's reply, which caused the judge to admonish those who thought the answer was funny. He said, 'I will have no laughter. This is a most serious case and laughter is most improper and most unbecoming.'

Mr Carrington said he thought the woman was then 'done for' and felt that any single-handed interference by him 'was a risk which it was un-necessary to incur'.

Mr Thomas Hayes, landlord of the Rose and Crown, took his place in the witness box, and confirmed that Cotton was the type of man who would have shown extreme jealousy if his wife spoke to other men.

Mr Hayes said he also went to the blood-spattered boat and when he asked Cotton what he had done he, too, was told, 'Nothing.' He said he struck a light and saw Mrs Cotton 'lying helpless and bleeding on the cabin floor'. Mr Hayes said, 'I think you have done plenty.'

Mr Hayes said he went back to their boat when they left his pub earlier in the evening not because they were drunk but because they had been quarrelling. He said Cotton had one glass of rum and his wife was drinking tea.

Dr Allen, a surgeon of nearby Whaley Bridge, said he was called to see Hannah Cotton but when he arrived she was unconscious. He said when he looked at her he concluded immediately that her chances of recovery 'were hopeless'. He said he later carried out a post-mortem examination and found wounds and bruises, 'which abounded on her face and head' and decided that a poker was the most likely weapon to have caused all the injuries including a fracture to the base of her skull.

By now all the prosecution and defence evidence was concluded and it was time for the jurors to hear once more conclusions and persuasive points for consideration from both sides before the judge summed up and asked for a verdict.

Mr Etherington Smith urged the jury to convict Cotton of murder because all the evidence, according to witnesses, made it clear that the elderly husband admitted what he had done and said he would have carried on and thrown her over the side of the boat into the water.

Mr Lawrance, Cotton's counsel, argued, quite rightly, that the prosecution brought the case and had to prove with all its evidence and beyond reasonable doubt that he committed the offence. He made it clear that he did not expect the jury to accept that Cotton did not kill his wife, but neither did he expect it to find him not guilty. He also argued that the evidence did not justify a verdict of murder. Instead after great and 'merciful' consideration of the facts, Cotton should be acquitted of murder and instead be found guilty of the lesser charge of manslaughter.

It was a desperate plea by Mr Lawrance and he said that there were 'certain discrepancies' in the evidence. He made his hopeless, last-ditch appeal and said the jury should 'discountenance the threats which the prisoner made to his wife because they were idle and meaningless owing to his drunken condition at the time he uttered them'. Cotton was seen beating his wife, heard to mock her wretched, grave situation and threatened to throw her overboard. The jury had powerful evidence to convict him of murder.

The judge summed up the evidence and made it clear to the jury that in his opinion, which they did not have accept, 'there was an utter absence of provocation in this case.'

The jurors listened intently and then retired to consider the short evidence of the trial. It did not take them long and within fifteen minutes they had reached their decision and decided that Cotton was guilty of murder.

Cotton made no reply when asked by Mr Justice Mathew if he had anything to say before sentence was passed. The black cap was placed on the judge's head. He said the jury had 'discharged a very painful duty but there could be no doubt he was guilty of the murder of this unhappy wife'.

Mr Justice Mathew went on to say that Cotton had 'conceived a vindictive feeling of hatred towards her and yielding to his wicked impulse beat her to death while she was unprotected'.

A reporter from the *Derby Daily Telegraph* reported that the sentence was listened to in 'breathless silence' by a crowded court and at the judge's last words 'there was a murmur akin to terror'. Cotton, who was leaning against the dock railing throughout the sentence, was calm and was accompanied to the cells below the court to await his execution.

He had three weeks of his life remaining before he would climb the steps of the gallows to be met by the executioner. Like all those facing execution there was hope that the Home Secretary might grant a reprieve. But any decision to interfere in the due process of the law was very rare and Cotton, like many others before him, presented nothing that would induce the Home Secretary to change anything.

There were some people who thought Cotton's 'neck might be spared' because of his age. On the court calendar of prisoners his age was given as seventy-five. Others thought he was sixty-one, sixty-six or seventy-four, but police inquiries were made before his trial and his age was eventually given as sixty-six. He could neither read nor write.

As the days towards his execution drew nearer it is hard to imagine how he felt when he realised that his life was about to end. Local reporters were, however, privy to some of the attempts made by the prison chaplain to try to make Cotton understand what he had done. One wrote: 'It is satisfactory to know that during his incarceration he has shown visible signs of repentance for he has paid very earnest attention to the solicitations of the prison chaplain, the Revd J. Hart Johnson, who privately admitted him to the benefits of the sacrament. He believed him to be sincerely repentant.'

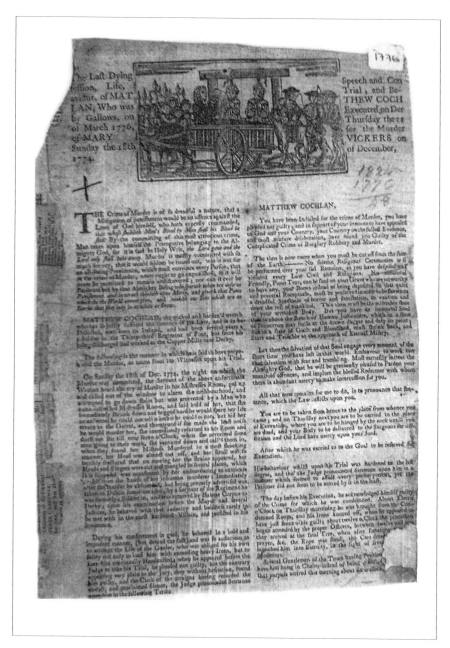

An artist's skill made certain the public knew that those facing the hangman always had a ride for their appointment with death.

By ten minutes to eight on the dark winter morning of 21 December 1898, John Cotton was as ready as he ever would be to meet his Maker – much more calmly and with less pain that he inflicted upon his wife. A mournful bell was tolling the minutes left, heralding the drama that was about to take place.

The scaffold was housed in a shed that was otherwise used to park prison vans, which meant Cotton, and those accompanying him to his end, had to walk around 40 yards from his cell in the prison building. Also waiting for Cotton was his freshly-dug grave beneath the front wall of the jail.

It was the first execution since August 1896, and was carried out from a huge wooden beam built into two walls about eight feet from the ground. A rope hung from the beam with its noose above a trapdoor, through which Cotton would rapidly disappear until his neck was jerked to a sudden and fatal halt.

Billington, a busy executioner from Bolton, and his son, were ready for their latest customer. With only three minutes to go, sheriff's representatives appeared at the door of Cotton's cell and in the final few moments of high drama 'demanded his body so that the sentence of the law might be carried out'.

Cotton appeared from the condemned cell and walked slowly and with difficulty as he and the chaplain and other prison officials made the short walk to the gallows where they were met by Billington and his son who pinioned his arms.

The *Daily Telegraph* reporter commented in his story:

Cotton, it was observed, required no assistance from the warders, but he nevertheless seemed to walk with difficulty. He had altered little during his confinement, but there was on his face a pale, haggard look, which his white hair considerably intensified.

However, he submitted meekly and even lent himself to the operation. This was expeditiously performed, and as the executioner was fastening Cotton's arms behind him the son was loosening his shirt collar.

Cotton was then conducted into the shed and placed upon the fatal trap, with his face considerably turned away from the few beholders.

Billington now set himself to complete his gruesome task, which he did quickly and quietly. The son attached and fastened the ankle straps and Billington at the same moment placed the rope around the old man's neck and adjusted the noose. Billington then withdrew from his pocket a white cap which he pulled over the wretched man's head, and then stepping instantly aside drew the lever. The chaplain singularly enough was at this very moment repeating the words: 'Oh Lord remember not the offences of thy servant' and as the culprit disappeared into the pit beneath there was an audible 'Amen' from the lips of those present in response to that appropriate prayer.

As many as desired looked through the trapdoor at the ghastly sight that was presented and Dr Greaves expressed the belief that death was quite instantaneous. Before the chaplain had completed the service, Billington and his son left the place almost unobserved, thankful no doubt, that their disagreeable mission had been fulfilled.

Outside there were more women interested in the execution and reports indicated that no word of sympathy was spoken of the wretched man who was meeting his doom within a few yards of where people stood.

Moments before he was hung, at 8 a.m., a bell tolled the early morning hour. People outside the walls waited and watched a pole for the appearance of a black flag to indicate the sentence had been carried out. Within seconds of Cotton dropping eight feet to his death, the flag appeared and fluttered in the wind to mark the end of John Cotton. The crowd then dispersed.

But as Cotton went to his grave he took with him a secret – one he had kept to himself for many years. There were rumours and gossip mainly among people who delighted in grisly matters. Some say Cotton confessed to murdering two other wives. One had disappeared and another died but there was never anything forthcoming that indicated whether he was a triple murderer.

The *Derby Daily Telegraph* had the last word on the death of Hannah Cotton, and one of the papers journalists wrote: "The annals of crime contain few cases in which cold-bloodedness and brutality stand out so conspicuously as in the murder for which John Cotton has just paid the extreme penalty of the law. It is easy to imagine that, living in a canal boat, the chances of domestic happiness and comfort, could not be so great as offered by a settled residence on terra firma, but nevertheless his surrounding could so scarcely have been so uninviting as to foster and develop the savage spirit which we know him to have possessed.'

Hannah Cotton did not deserve the treatment she suffered and the behaviour which led to her death. She never gave her husband cause for concern when she spoke to other men and during John Cotton's trial she was referred to as a 'well conducted woman and endeavoured as well as she could to comply with the wishes of her ill-tempered consort'.

12

CAN YOU KEEP A SECRET?

Everyone has something to hide. It doesn't make any difference who they might be. A secret can be kept hidden deep inside their brain where no one can seek it out. Part of their life is locked away from prying, inquisitive people and is usually safe, as long as they keep it to themselves.

This much I have learned during many years as a court reporter covering cases all over England. But one thing I was quick to grasp, is that if you are going to commit an offence, keep it to yourself, work alone, don't write anything down, just memorise whatever you plan to do, but above all keep it away from anyone else.

Once others find out, the trouble starts. Take as an example the story of two brothers from Derbyshire who were treated differently by their wealthy father. One had everything he wanted while the other was a second-best Cinderella. The older brother was cruel and several years later had a daughter who, unfortunately, became pregnant out of wedlock. A son was born alive; he was wrapped in warm clothing and taken away in the dead of night and hidden under a haystack in a field at Annesly in Nottinghamshire. The following day the child was found dead.

Now it is bad enough for a cruel father to treat his daughter in such a disgraceful way. But William Horne made a mistake. He asked his brother, Charles, to ride with him to dispose of the little human being. To ask someone you do not treat well to become privy to such an unpleasant task was courting disaster, and thirty-five years later William Horne was to pay with his life for his carelessness.

William Horne was forty-one years old, born on St Andrew's Day in 1685. He and his siblings were given a good education at home by their father, described as 'one of the greatest scholars of the time'. They learned Latin and English but William lacked morals, which in turn led him to a life of debauchery and perverted lust.

A local scribe who recorded his wasted life, wrote, 'William Horne was the eldest and most favourite child, but whether owing to anything more pleasing or witty the father discovered in him than his other children we are not told, yet certain it

is that he was much preferred before them; being often indulged with a horse and money in early life, to ramble about the country from one place of diversion, while his brothers at home were made drudges in the farm, to support his debaucheries and idleness abroad. We wish we could say some care had been taken of his morals, but little can with truth be offer'd.'

The scribe continued with his diatribe caring little for feelings of the family of William Horne, who, by now, was heading for a meeting with his Maker. 'It were much to be desired that his vices could be exposed without being obliged to name the partners of his guilt; but as that cannot be we must blush for him, when 'tis asserted that not content with debauching his mother's servants he added the abominable crime (here the scribe was too embarrassed to name the offence) with his sister.

A young gentleman of fortune paid his addresses to one of the sisters, but he soon discovered the unnatural commerce between the parties, so that the courtship was broke off almost as soon as it began.'

It seemed Horne's quest in life was to bring misery to others. He gave nothing, but instead brought despair, grief and gloom to those closest to him. His father piled gifts upon him, but shortly before his death, at an amazing 102 years old, he fully realised the type of son he had nurtured for years.

His son continued his debauchery at an alarming rate and by one woman had several children. She was well advanced in her pregnancy of another child, when Horne decided to remove her in 1722 from their home village of Butterly near Derby and send her to Nottingham for 'lying-in'.

But she could not face being parted from her lover and the following day returned home, much to the annoyance of William Horne. She was stopped by local parish officials and kept in a house overnight 'so that she might swear the child to the true father'.

But some of Horne's character must have rubbed off his mistress because under pressure she named Humfrey Ellis of Tumble Street, London, as the father, though no such person existed. A girl was born but died when she was around fifteen or sixteen years old. Another daughter was born and she was described as 'a pretty, sensible, well behaved young woman'. She later met and was courted by a rich suitor who wanted to marry her but Horne refused to give her £50 'and she lost a good husband by the cruelty of her father'.

By now, the aged Horne Snr was at last beginning to see the foolishness of his ways over the years and his misplaced indulgence of his son. It was at this time, around the spring of 1724, that one of William Horne's daughters gave birth to a healthy boy. It was said that the child was taken away and reportedly sent to a nurse.

Now who the father of this child was remained a mystery but with William Horne's misguided desire for sex with many women, it could not necessarily be dismissed that it was his. By now the younger brother must have realised something was wrong because he told his father that soon after the child was born he and William disposed of the baby. He said it was taken away in a bag and later placed under a haystack and the following morning was found dead.

The distraught father ordered Charles to keep the secret until the old man died. 'He being, a good deal frighted with this relation, insisted on Charles never giving even the least hint of this affair during his life, and it is presumed, in obedience to his father's commands, it was kept a profound secret 'till his death, which was in or about the year 1747', wrote the local scribe.

But in spite of William Horne's 'licentious conduct' his father continued to pamper him and bestow gifts upon him. In this 'blood-is-thicker-than-water' attitude, the aging Horne Snr passed into his wayward son's possession real estate. Money, about £100, household goods and cattle, were given to Charles.

Shortly after the old man died, William angrily decided that his brother should pay for all the funeral expenses. Not content with that he ordered Charles out of the family house and would not let him enjoy what his father had left him.

The dreadful secret that was being kept by Charles gradually began to wear him down and William, by ignorance or otherwise, never thought his brother would ever tell anyone of what happened to the baby.

Time did nothing to change the character of William Horne even though he was master of his late father's estate. 'He no doubt might have lived with some degree of credit, and reputation, but he was of so penurious of disposition, that it's said he never did one generous action in the course of his whole life', wrote our scribe, 'and it is really a strong proof of a most sordid, covetous temper, that tho' he knew his brother Charles was a master of a secret of the last importance, yet he would not give him the least assistance, nor would he bestow a morsel of bread on his brother's hungry children, when they went, as they often did, to beg at their stony hearted uncle's door.'

By now the years had passed. The relationship between the brothers had not improved. Charles was taken ill with the gripes and neighbours who visited him thought that his health was in great danger. One decided to call on William for help and asked for some rum to ease his brother's pain. But he was refused and told by William that he would do nothing to save his brother's life.

Sometime later William became involved in an argument in a local ale house about the killing of game when the other man called him an 'incestuous old dog'. The accuser was sued and William won his case. From this moment the days for William Horne were numbered and before long the secret that his brother had honourably kept for years despite his sibling's behaviour would become public knowledge.

The man who made the slanderous remarks, a Mr Roe, decided to make his own investigation into 'things he had heard' about William Horne and the death of one his children. People talk and gossip and they remembered idle remarks made by Charles Horne that his brother had 'starved one of his children to death'.

A justice of the peace in Derbyshire issued a warrant for the apprehension of Charles Horne so that whatever allegations were made could be fully investigated. News travelled rapidly, and William Horne became concerned and invited his brother to his home.

As we are well aware there was no love lost between the two brothers and the secret that had taken root in Charles' memory began to come to the surface.

This was something that William had dreaded and he sought an assurance from his sibling that he would not tell anyone what they had done with the baby in 1722.

William asked his brother if he 'would swear his life away' to retain the secret but the Charles, who had survived years of unhappiness at the hands of his father's favourite son, turned him down. William promised to be a friend to him but the pleas reached deaf ears and Charles said, 'I must and will swear the truth. Brother, you have not the least reason expect any favour from me.'

Charles, despite his promises to tell the truth at all costs, made an amazing proposal in a bid to save his brother. He said if William gave him £5 he would leave immediately for Liverpool and take a ship to another land. A condition was that William should look after and take care of Charles' wife and children.

But with his future in jeopardy and his brother's promise, William still refused to help. 'To this easy proposal the squire would not consent, chusing [sic] rather to run all hazards than part with so small a sum as five pounds.'

William Horne's meanness and obstinacy finally put his life at risk and the secret the brothers had kept for so many years would soon be public knowledge. However, justices of the peace in Derbyshire were loathe to issue a warrant for the arrest of William Horne. Instead a magistrate in Nottinghamshire 'who struck by the atrociousness of the crime' took steps to make sure Horne was arrested. He was questioned before two justices for several hours and after listening to compelling evidence decided to commit him to Nottingham Assizes for trial 'charged with such monstrous crimes and had little to offer in his defence'.

William Horne's miserable life was crumbling around him and he could not fail to realise that the terrible secret his brother had kept for thirty-five years would eventually condemn him to death. He was to appear before the Lord Chief Baron Parker on Saturday 10 August 1759 and after a trial that lasted almost nine hours, having started at six in the morning, he was convicted and sentenced to death.

William Horne claimed he was maliciously prosecuted and accused of a crime about which he knew nothing. Charles said he 'wished every tongue might rot out that spoke in favour of the prisoner; and that he prosecuted him out of spite and malice'.

William Horne was arraigned in front of the jury and crowds in the public gallery on Saturday 10 August 1759 accused at the 'instigation of the Devil' on 18 February 1724, of the murder of a three-day-old boy. The indictment covered several hundred words and included 'not having the fear of God before his eyes'.

He pleaded not guilty and the clerk to the court then asked him, 'Culprit how wilt thou be tried?' Horne replied, 'By God and my country'. The clerk answered, 'God send thee a good deliverance.' In most cases it took longer to read the indictment than it usually took a jury to reach a verdict.

The first witness, Charles Horne, gave evidence to a hushed court as jurors and people in the public gallery listened in deep silence to words that without any doubt were so dramatic that William Horne could see the hangman's noose in the distance.

He said that at ten o'clock at night his brother went to him in his room and told him that he must take a ride with him. 'He took a male child out of the kitchen chamber which was only three days old. I mounted a horse in the yard and we went straight to Annesly. I held the bag and my brother put the child in. I tied the bag and we went straight to Annesly. My brother and I carried the child in turns. When we came near Annesly my brother, the prisoner, alighted from his mare and asked me if the child was alive on which I put my face to the child's face and said it was alive,' he said.

The damning evidence had its effect on the jury. They never took their eyes off Charles Horne and listened with amazement and disbelief as he related his story under oath. 'He then took it from me in the bag and left me after bidding me stay in the lane till he returned. In about a quarter of an hour he came back. On my asking him what he had done with the child, he said he had laid it by a haystack and covered it with hay. My father was then living but did not know of it till some time after, but when he did, he charged me not to speak of it.'

Charles Horne continued and said that one of the workers on his father's farm stopped him and said that there was 'some strange news from Annesly'. That a child was found there under a haystack 'and thrown over a hedge with a fork'. Also that a man went to fodder his cattle and had ran his fork into the bag. 'I should have made a public discovery of this much sooner if my father had not injoined secrecy.'

But the pressure on Horne in keeping the secret began to take its toll on him and he confessed to the jury that he told one man about the baby then spread the information to a Mr Cook in Derby. He was advised to seek help from Mr Justice Gisborne, a High Court judge who gave him the most bizarre advice from someone in the legal profession.

'Mr Gisborne said I had better be quiet as it was of long standing and might hang half the family,' said Charles Horne. 'Mr Cook also said a discovery of this sort might much injure my brothers abroad (in the local area).'

He said he repeated his secret to two other men and then, about four years later when he became seriously ill, repeated his story to a John White of Ripley, Derbyshire. 'I desired he would advise me what to do. Mr White said it was a "nice affair" and he could not tell how to advise.'

Sometime later a warrant was issued for Charles Horne to give a statement about the child. 'My brother hearing of this ... wanted to know who had granted the warrant and to tell me they could not force me to swear against the prisoner if I had no inclination to do so. I told my father of the murder not long after it was done, and he insisted that I should never speak of it.

'Said he: "Charles if thou shouldst declare this, when thou are dead, the people will walk over thy grave and say: 'here lies the man that hanged his brother'."'

There followed one by one a long list of witnesses who in turn told to the jury what they knew. Thomas Limb was one who lived at Annesly and he said that John Wooton was the farm worker who had found the bag with the baby inside. 'He came to my house about the middle of February 1724 ... and said while he

was foddering he found the bag near my house and said he had put it over into my croft,' said Mr Limb.

'Upon this I went with him, to see what it was, and we opened the bag and found a dead male child in it. We took the child to my house, and my wife took the child out of the bag to see if there was any life in it, but the poor child was quite cold and dead. My wife said it was four days old.'

Reading evidence and seeing what the witnesses told the court almost 250 years ago is a strange experience. People I never knew come to life and it is easy to picture in the mind's eye these folk taking their places in the witness box and talking about something that will probably never be referred to again. Then they will disappear back into the pages of newspapers to remain undisturbed for another 250 years.

We have to imagine what these people looked like and how they dressed because in those days there was no such thing as a photograph. It would nice to hear them talk because the language they used then would obviously be strange to our ears.

But there was something about the way they used words and expressed themselves. No doubt the way we speak would be strange to them. I have never seen in any documents the modern phrases 'you know' and 'I mean'.

Their articulation and ability to communicate is something that, sadly, has been lost over time and will probably never reappear except in books.

John Topham was another witness who told the court of a meeting with Charles Horne about fifteen years earlier, when he and another man went to Butterly to speak to Charles. 'We found him in the stable and he looked very sorrowful. I asked him what was the matter. He said he and his brother had had some words', said Mr Topham. 'Says I "he does not use you well" and he replied he knew that which would hang his brother "and yet he uses me thus". I then asked him what it was and he told me that he and his brother, the prisoner, had above twenty years murdered a child and left it at Annesly.'

Mr Topham said the following day he and another man who heard Charles Horne's confession went to Annesly and asked if anyone in the neighbourhood had any knowledge of such a child being found. 'We were informed by several people, particularly a landlady, that about twenty years earlier such a child was found', he said. 'Three or four years after this I told the prisoner of it. He gave me ill language and never invited me to his house after.'

Another witness recalled what he saw of the baby thirty-five years earlier. 'The child was quite dead and was a fine male child. There were no marks of violence upon it, nor any bruise. I examined it all over. It was a fine boy and I am of the opinion it was killed by being left out all night in the cold and so it starved to death', said John Weightman.

There were many others who told their sad stories of the babe that lived but three days. They listened with care as Charles Horne made numerous attempts to unburden his conscience and free himself of the miserable secret he had kept for so many years.

John Walker gave his evidence and told of the time he spoke to William Horne who admitted he knew about the warrant issued against his brother in order to

be questioned about the death of the baby. 'By his desire I went to Charles to know where the warrant came from, and I offer'd Charles money to make the two brothers friends', he said. 'He had me tell Charles they could not make him swear what he knew against his inclination. The prisoner said to me: "What, would they tear my sisters out of their graves for a thing done thirty years ago? Tell Charles he can't hang me without hanging himself and that if he behaves properly I will be a friend". The prisoner never denied the fact to me or said he was innocent of the murder.'

Although William Horne had pleaded 'not guilty' to murder, as was his right, the evidence against him was gradually building up to a cast-iron case and there seemed little chance that the prosecution could fail to achieve a conviction.

William Horne tried everything to avoid the authorities but the local constable was just as determined to get his man. One night, around eight o'clock, John Turner, the policeman at Annesly, went with three other men to Horne's house and demanded entry but were turned away by a servant girl.

This made Constable Turner all the more determined to get his man and left the other three to remain on guard at the door. He returned the following morning to continue his relentless pursuit of William Horne and, after knocking on the door and threatening to break it down, he was told by a maid that Horne had gone out.

After the four men were allowed in they searched the house but there was no sign of Horne. But Constable Turner was more tenacious and single-minded than ever and at the encouragement of one of the other men, decided to make a second search of the house.

'In one of the rooms there was a large box. We determined to know what was in it', he told the jury. 'Mrs Horne, the prisoner's wife, said it contained nothing but her bed linen. Samuel Roe (one of the constable's three companions) said he would look into it and offered to break the lid; then Mrs Horne opened the chest, and Mr Horne, the prisoner, started up in fright without his hat and wig.'

Mr Roe also gave evidence. 'We searched every room and passage in the house very carefully to no purpose. At last I fixed my eye upon a large old chest in one of the rooms, in which Mrs Horne said there was nothing but table linen and sheets, but (I) insisted upon looking into it, and resolved it should be broke open; she then unlocked the chest and Mr Horne came out of it, shaked me by the hand and said: "It was a sad thing to hang him for his brother Charles was as bad as himself, and he can't hang me without hanging himself".'

Mr Roe said that a short time later Horne was in the parlour when he turned towards the wall and said: 'Damn the cock-bag'. (This was the white bag in which Horne had placed the new-born babe and which was found under the haystack.)

This was the end of the prosecution's case and it was now Horne's turn to tell his side of the story. At the time of his trial, defendants were not allowed by law to give evidence on oath.

However, prior to 1898 a defendant was allowed to make a statement from the dock in his defence and that it what Horne did. He told the court, 'I am accused of a crime I know nothing of. I am persecuted maliciously.'

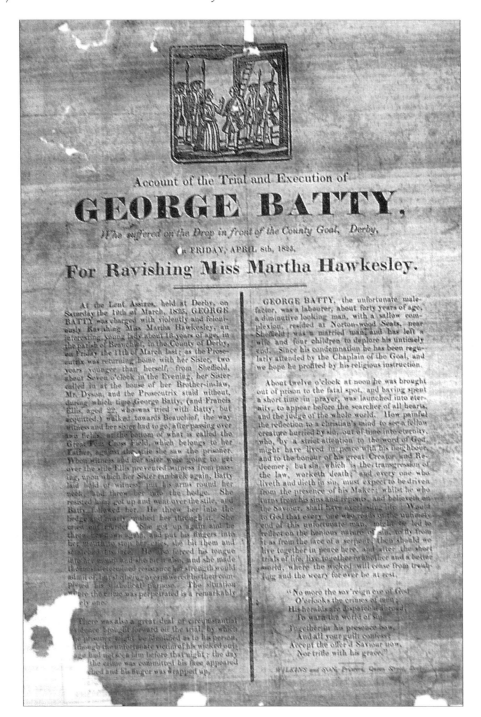

As far back as 180 years ago, sex offenders were sentenced to death.

The first witness to appear for Horne was a man named Robert Moore who said he had spoken to Charles two months earlier and the younger told him, 'If the prisoner would not give him something out of the estate and let it go in the right line he would hang him right or wrong.'

Sarah Eyre took her place in the witness and, after taking the oath 'to speak the truth, the whole truth and nothing but the truth', related to the court that she knew both brothers. 'Charles told me that the prisoner had strove all he could to take his bread away and that he would say and swear anything to hang him', she said.

'I said God will never forgive you; he said: "Thou fool the Devil has as much power over me as he can have". He threatened to mob me if I came to the assize to give evidence in favour of his brother.'

Another woman witness said Charles Horne told her, 'I with somebody would lie in the goss [sic] and shoot my brother.' John Buxton said he spoke to the younger brother some months before the start of the trial and told the jurors, 'He declared to me another time he did not want to hang the prisoner tho' he had cheated him out of his fortune.'

And so it went on. Witness after witness presented their evidence in the hope that it would greatly discredit Charles Horne and save the old brother from the gallows.

The court was told by another of William Horne's friends that Charles 'would swear his life away' if his brother would not help him by giving him some money. Another told that she met Charles while on her way to Ripley some months earlier and he said if William had given him some money, he would not have sworn against him.

Eventually, all the defence witnesses had their say with all disclosing fairly much the same the same evidence.

The judge then summed up and within half an hour of being sent out to consider their verdict the jurors decided William Horne was guilty of murder.

William Andrew Horne was born on 30 November 1685 and was seventy-four years old when he was hanged for murder outside Nottingham jail on Tuesday 11 December 1759. He suffered the further indignity of being dissected and buried in pieces.

While awaiting his execution he made a confession and gave his account of the murder of the baby. He said he had 'no intention that the child should die, that to preserve it alive, put it into a bag lined with wool, and made a hole in the bag to give it air'.

William Horne was a desperate man, and wretched people without hope usually attempt to justify what they have done. He was no exception and claimed the baby was a 'present' for a man he knew and that he and his brother had travelled to Annesly to give it to him.

He said he intended to lay it at the man's front door at a strangely late time of the night but was frightened off by dogs that barked constantly. He said he was 'disappointed and at last determined to lay it under a warm haystack in hopes of it being discovered'.

As he waited for the sentence to be carried out Horne 'was quite resigned and behaved in a becoming manner'. He said he forgave all his enemies 'even his brother Charles, but that at the Day of Judgment, If God Almighty should ask him how his brother behaved, he would not give him a good character'.

And so another life ended because someone could not keep a secret.

13

GEORGE SMITH

Many children argue with their parents. It's a part of growing up. Thankfully, that is usually as far as it goes. But sadly George Smith could not accept being criticised by his father and in a fit of violent temper stepped across the line. He quietly and carefully walked behind his father's chair and, with deliberate, cold-blooded malice, killed the old man with a single shot to the back of his head.

The young Smith lived at the family home in Bath Street opposite the Primitive Methodist chapel, in Ilkeston, Derbyshire, with two other brothers – Henry and Edward, their sister, Sarah and their father. Another brother, Samuel, lived with his wife in a house further down Bath Street. Their mother had died some years earlier.

Joseph Smith was a hardworking forty-six-year-old shoemaker, careful and economical with the money he earned. Another son, Henry, worked with his father, and a young brother went to school. George was a lacemaker but at the time he killed his father he was out of work and planning to get married. He wanted 'pecuniary assistance' from his father, who was not willing to help because he believed that if his son wanted something he should earn the money.

George had managed to get hold of his father's bank book and, with two friends, took off to Nottingham to try to withdraw money. The bankers were suspicious and refused unless he had permission from his father. But he managed to obtain £1 from a local wine merchant and return home Bath Street where his father and two brothers had gone to bed.

Joseph Smith was worried about his twenty-one-year-old son, who had not returned home and so went downstairs to wait for him. George had made a suggestion that he might want to join the army. His father looked around the house to see whether he had taken any clothes when he came across some paper on which was written something that made him uneasy. The contents of the note remained a mystery.

Meanwhile, the younger son, Henry, was getting dressed to go down to his father when George returned to be confronted by an angry Joseph Smith who said, 'You have got yourself into trouble and you must get yourself out as well as you can.' It is believed that this remark referred to an affiliated case 'to the pecuniary wants of his son'.

At this moment there was an explosion from a pistol and the brothers and sister upstairs ran to open a window and shouted out 'Murder!' Henry then went downstairs and found his father stretched out and lying in a pool of blood. The shot entered the back of his head and death must have been instantaneous. The local police constables appeared almost immediately and George was taken into custody.

A local scribe who wrote a history of the murder, the subsequent trial and eventual execution, stated:

By this time crowds of people had assembled in and about the house and were horrified to find their worst fears realised. The mental agony of the other two lads seemed uncontrollable and they wept alternately over their father's corpse.

Bereft of a father, and that too without a moment's warning and when they least expected it, and bereft of a mother, these orphans seemed entirely friendless and completely overwhelmed with grief; while their unnatural, unfeeling and drink-maddened brother was raving and protesting his innocence and singing in the most frantic manner: "Here's the heart that will never fail, to swing under a gallows or under a rail".'

A search was made for the pistol and it was later found in some distance away in the garden of another house. George Smith continued to deny any part in the killing of his father. It was discovered that he bought the pistol from a Daniel Webster in Nottingham and when asked why he needed it George replied he wanted it 'to fly pigeons with when he was racing'. Mr Webster was satisfied with the answer and George handed over four shillings for the pistol. He bought ammunition from another shop.

George Smith was arrested within hours and taken before local justice of the peace, John Radford, who, after satisfying himself with the evidence against the prisoner, committed him for trial at Derby Assizes on Monday 29 July 1861.

His trial started at 9 a.m. He walked into the dock, well dressed, with a pencil and notebook and in 'excellent spirits'. He was arraigned by the clerk to the court and pleaded 'not guilty' to the murder of his father.

A jury was sworn and Mr Boden, prosecuting, outlined the case to the jurors in 'very clear and temperate speech'. The twelve men selected to try George Smith looked toward Mr Boden and listened intently as he told them that the prisoner 'was charged with a crime so monstrous, and indeed so unnatural, that it was very important you should thoroughly sift the facts as they would be brought out in evidence'.

Centuries ago, cases of such seriousness were completed in hours with the prisoner totally at the mercy of a corrupt legal system when a jury would consider the facts and reach a verdict all within minutes.

Mr Boden went on with an outline of the evidence against George Smith and told the jury that the dead man 'was of industrious and frugal habits' and lived in one of Ilkeston's principal streets. Hours before he was shot dead, Joseph Smith and his son, Henry, worked until around 7 p.m. and then went to the home of his eldest son, Samuel. Henry and his younger brother, Edward, returned home about 9 p.m. and their father followed an hour later. He made himself some tea, sat down for a while then went to bed in the room he shared with Henry.

Everyone in the court was silent and all eyes were on Mr Boden as he continued to outline with emphasis and detail the prosecution's case. 'About midnight the deceased and his son, Henry, were awoke by a noise downstairs and he told his son to get a light and the father proceeded downstairs. Henry followed him but his father told him to return to bed,' said Mr Boden.

'The father remained downstairs and lighted his pipe, sitting down in the house-place [a living room]. In a few minutes afterwards the son upstairs heard some conversation going on between the prisoner and his father and for a minute or two all was silent and then the report of a pistol was heard. The sons were greatly alarmed and they threw up the window and began to cry out "murder". The neighbours were attracted to the spot by their cries. They found the father lying on his back across the hearth, with his head in the corner of the house-place, and quite dead.'

Aaron Aldred, a neighbour, looked to see what was the cause of death then looked for the pistol but it could not be found. George Smith, who had been outside, came in and Mr Aldred in a quite matter-of-fact way said to him, 'Why, George, you have murdered your father.' George replied, 'No, I did not murder him; I am innocent. I don't know anything about it; my father has done it himself.'

Mr Aldred then asked, 'What has your father done with the pistol if you did not shoot him?' 'My father put the pistol in the oven after he shot himself and I made away with it.' An amazing piece of agility on the part of the mortally wounded Mr Smith, and a defence that would without doubt crumble under the scrutiny of jurors; they reached their verdict within minutes after listening to hours of evidence.

Within the hour, Mr Boden had completed his opening and called the first of his witnesses – the defendant's older brother, Samuel. He told the court about his family and said that Sarah was married to Aaron Aldred, the man who found the dead Mr Smith. His said because of his frugality and hard work his father managed to buy four houses and had between £140 and £150 the bank.

He was followed by his young brother, sixteen-year-old Henry, who immediately broke down when he went into the witness box and began to cry. He was allowed to compose himself then started to give his evidence. He told the court:

I have lived with my father all my life, and worked with him at his trade. I was working with my father on May 1st (the day before Smith senior was killed) and when we left work we both went out.

I left my father and joined a friend. It was about twenty minutes past ten when I returned (home). My father was lying on the sofa and I asked him if George had come. He said he had been in a time or two [sic] but was not then at home. He told me and my brother to get some milk for his supper, and after we had done so we were to light a candle and go to bed.

I went to sleep and at about twelve o'clock when I woke my father told me to go downstairs and fetch a candle. He then went downstairs. He called for me and showed me a note, stating that he thought George had gone for a soldier (to enlist) and that he had left that paper behind him. He then told me to go to bed again. (That was the last time Henry saw his father alive.)

The next thing I heard was the opening and shutting of the door leading into the yard. I heard my father say: 'George have you been to Nottingham today?' George replied: 'No.'

My father then said: 'Are you sure?' 'I am sure,' said George. My father then told him he should not have his door open at improper hours. I did not hear anything more said after this till I heard the report of a pistol. We were frightened and if it had not been for me my brother (Edward) would have jumped through the window.

Our legs were hanging out of the window. We called out: 'Murder'. After we had been down for sometime my brother, George, came in. I told him he had killed my father. He said: 'I haven't, my lad.'

Henry completed his evidence and was followed into the witness box by his thirteen-year-old brother, Edward, who gave similar evidence, which was corroborated by his sister, Sarah, and her husband, Aaron.

The local police constable, George Carline, was the penultimate witness, who stood straight-backed in the witness box, and told the jury he was on duty on the night of 1 May and heard the cry of 'murder' coming from the Smiths' house. 'I went to the house and found the deceased lying on his back against the fireplace. Henry Smith said: "Oh, George, you are my brother and you have shot my father". George said: "Don't say so, I am innocent". George then threw himself on his father and kissed him.' Without any evidence or a weapon, Constable Carline said he pulled George off his father's body 'and I charged him with shooting his father. I took him to the lock-up. On the way he said: "My father took something off the hob, and shot himself in this way".' The constable made a motion with his left hand.

The last prosecution witness was Detective Edwin Davis, who claimed that on the way to Derby jail, George Smith told him that his father had threatened to shoot himself 'for a long time past'.

Mr O'Brian, the defence barrister, made an 'eloquent appeal on behalf of the prisoner', followed by the judge's summing up. The jury was then asked to reach its verdict and, within three minutes, decided that George Smith was guilty of wilfully murdering his father. A local journalist said that Smith received the verdict 'without changing his countenance and was apparently unmoved at the result'.

'The learned judge then assumed the black cap and passed sentence upon the

prisoner in a very feeling manner. The prisoner received the sentence without apparently manifesting the slightest emotion and it was remarked that the most hardened of criminals could not have evinced more stolid indifference at an ordinary condemnation.'

As he left the dock, Smith waved his arms to people in the public gallery 'as though he had achieved some great victory'. He turned to his brothers and shouted, 'Goodbye, lads; goodbye, Mark; we shall meet in Heaven where the Judge will judge others as well as myself.'

The terrible thing he did gradually dawned upon George Smith as he left the dock after his so-called trial to be taken to the condemned man's cell at Derby Prison. He was in a highly emotional, tense and agitated state when he met his siblings in a passageway and none of them were able to have a rational conversation. Smith merely and affectedly spoke only to say that they would all meet one day in Heaven.

He was met by the Revd Henry Moore, chaplain to the county jail, who stayed with him for a while before he was taken, in a more subdued condition, to the prison. The turnkeys stayed with him night and day until his execution date and he was visited daily by the chaplain.

On 31 July, only seventeen days before he was to make the walk to the gallows, Smith was visited by the High Sheriff of Derbyshire, W. T. Cox. He later told officials that when he first went into Smith's cold, dark, damp cell, he appeared 'dogged and sulky' as if he did wish to see anyone. Mr Cox was recorded as saying Smith was 'indulging in the hope that the extreme sentence of the law would not be carried into effect'. The High Sheriff told him his hopes were 'groundless. The prisoner's eyes were filled with tears, and he evidently felt the force of the remarks that were addressed to him.'

Revd Andrew Knox, who accompanied the High Sheriff, reminded Smith – as if he did not already know – about the 'heinous' crime he had committed. The Reverend then encouraged Smith to take part in prayers and when they were finished the 'wretched culprit lay with his face covered in the bedclothes'.

Smith said he believed in God and hoped to be pardoned by Him, but not in Jesus Christ. Mr Cox emphasised to the wretched, hopeless man the need for repentance, remorse and confession as there 'was no hope for him in this world'.

The night before his execution he was described as 'rather restless' and he spent most of the time writing and reading.

Hangings were a big social event on the county calendar and people travelled from all parts of Derbyshire by cart or on foot to meet up with relatives and friends. It was a day of excitement and akin to a carnival atmosphere as people waited for the public execution outside the gates to the prison. They talked and shouted to one other, and children laughed and screamed at each other as they ran around, totally unaware of why their parents had brought them to the prison.

In all it was estimated that between 20,000 and 30,000 people pushed and shoved as they crowded together to wait for George Smith to take one last, short walk to his doom. The ministers still concerned themselves with his spiritual welfare and walked slowly with Smith towards the gallows and Calcraft, the waiting executioner.

Calcraft, who was one of the leading and busiest hangmen in the Midlands, adjusted the rope around Smith's neck and covered his head with a cap. He moved to Smith's side, drew the bolt, and a trapdoor beneath Smith's feet opened within a split second. His body dropped and his full weight was jerked to a stop by the noose. The crowd was deathly quiet. But when his neck was heard to snap the silence was broken and tens of thousands started to cheer as 'the wretched man was launched into eternity'.

Part of the revelries was for someone to write in rhyme about what was called 'The last dying moments of George Smith', when he confessed to the terrible thing that he had done. Here is what was written:

> And I am doomed to die,
> The solemn bell for me does toll
> (For killing my own father dear),
> On Derby's gallows high;
> Oh! what a dreadful sight to see
> Oh, dear! What have I done;
> A cruel deed, and I must leave –
> Scarce aged twenty one,
> On the fatal drop I must appear
> For killing my own father dear.
> *
>
> At Ilkeston we did reside,
> And kind he was to me;
> But I was a sad and wicked son,
> As everyone could see.
> I caused sorrow, grief and woe,
> Pain, wrangling and strife.
> To rob him, I determined was,
> And took away his life.
> No one on earth will pity me,
> On Derby's sad and fatal tree
> *
>
> My father kindly spoke to me,
> Upon that fatal night,
> And while he sat upon his chair,
> A smoking of his pipe,
> I fired the dreadful weapon: -
> Alas he spoke no more;
> Then momently fell weltering
> All in his crimson gore.
> Murdered him to gain his wealth,
> Then said my father shot himself.
> *

SENTENCES of the PRISONERS,

Confined in His Majesty's Gaol and Houses of Correction for the County of DERBY, who have taken their Trials at the General Quarter Sessions of the Peace, held at Chesterfield, on Tuesday the 5th of August, 1828.

The table below lists prisoners' names, their offences charged, committing authorities, dates committed, and sentences. The text is too faded to transcribe reliably. Legible names include:

1—JOSEPH WESTON
2—GEORGE PARKER
3—JOHN BEARD
4—JOSEPH TURNER
5—WILLIAM CAPEWELL
6—WILLIAM WINT
7—THOMAS BROOKS
8—GEORGE REDFERN
9—GEORGE COWPE
10—MARY HUST
11—WILLIAM BAKEWELL
12—FRANCIS HARKIN
13—MICHAEL WILMOT

CONVICTIONS
JOSEPH EADEN
MILICENT HILL
JOSEPH CARR
RICHARD HANCOCK
JAMES CARNEY
JOHN PINDOR
BENJAMIN JUDD
WILLIAM DAUGHTY
GARRATT BLACK
CORNELIUS MACDONALD

VAGRANTS
WILLIAM EDWARDS
JOHN BRIGGS
CHARLES MARSH
CORNELIUS CAWFIELD
BRIDGET FINNERLIN

BASTARDY
SAMUEL MARRIOTT
THOMAS HUTCHINSON
THOMAS BORNER
THOMAS CARLINE
MARY NICHOLS
WILLIAM GENT
ROBERT EYRE
MICHAEL CAMM
JOSHUA HARRISON
WILLIAM BRISTOL

After every session of court the public was made aware of the sentences passed.

"I suddenly sent my father
Into his silent tomb,
And I must die on Derby's tree,
In vigour, youth and bloom.
For this dreadful deed, as you may read,
A jury did try me,
And the sentance [sic] I received ,
The twenty ninth of Last July,
Oh! young men a warning take,
Of my most untimely fate.

*

Oh! children be obedient,
Unto you parents dear;
Think what occurred at Ilkeston,
In the county of Derbyshire;
It was there my dearest father
So cruelly I did slay
When in a state of drunkenness
Upon the first of May
On the 16th of August, I,
George Smith, a murderer must die.

*

The hangman is approaching, -
The moment fast draws near,
And numbers flock my end to see,
From around Derbyshire.
Oh! cursed drink, that cursed drink,
As caused my downfall,
My glass has run, my time has come,
Oh, God receive my soul.
I see my wickedness too late,
And own that I deserve my fate.

No matter what George Smith said or felt during the weeks up the day of his death at a very early age, his pleas to others to stay on the straight and narrow path fell mostly on deaf ears. People in those days were dreadfully poor. There was little work and fathers – who were capable of breeding if nothing else – had mouths to feed. Crime was, for many, the only way, and they knew what would happen if they were caught.

14

GOTTA PICK A POCKET OR TWO

During the seventeenth, eighteenth and nineteenth centuries, a majority of offences on the criminal calendar ended with the villain swinging at the end of a hangman's rope in front of a crowd of rapturous, cheering onlookers outside the local jail.

It was a kind of sporting event with the Roman-type gladiator in the form of the local executioner – regularly a man named Billington from Bolton assisted by his son. The crowds loved it and came from all over Derbyshire for these events, which were held three or four times a year when High Court judges dispensed a form of barbaric justice at the local assizes.

Age did not matter. If a villain committed an offence, the odds were that the sentence was death. There were plenty of hangings because more often than not an offender had committed the ultimate sin – from sheep stealing to murder. It was 'off with his head' – or to be precise stretch his neck – and the only way he would be forgiven was when he met his Maker.

Few, if any, escaped the death sentence once it had been imposed, and in all my years of researching cases I can only recall one person being reprieved – a fifteen-year-old in Staffordshire. He was convicted of killing a nine-year-old boy for his wages of one shilling and sixpence. There was never a record available, unless I missed it among the hundreds of sheets of paper I scanned, and I never found out what happened to him after he escaped the clutches of the executioner.

John Porson was only twenty years old and had become a dab hand at picking pockets and taking part in other crimes. He travelled the country helping himself to things that did not belong to him and generally becoming a nuisance to people who objected to him getting them in his sights.

He was a regular to Derby where he stole from a mercer's haberdasher shop in the city and from local stallholders in Derby market. Porson kept a record of all his crimes in his head and shortly before he was to die decided it might do him some good where he was going if he owned up to his petty villainy.

His last crime was stealing eight guineas when he made a diversion to Ashbourne a small Derbyshire market town, and helped himself to the money from the pocket of local farmer Mr John Johnson who was visiting the popular county fair.

The prosecutor at Derby Assizes insisted that the young thief was the main suspect who deprived him of property after picking his pockets and refused to take 'no' for answer. But Porson had a cast-iron defence. At the time he was in Manchester prison serving a sentence for other offences.

A certain group of people made a living for themselves by writing the confessions of the condemned waiting to be hung and in the case of Porson there was no exception. He was a well-qualified thief and pilferer and made no excuses for his behaviour.

Well, how did young Porson get started? He was born at Retford-in-the-Clay, Nottinghamshire, not too far from Derby. When he was around five years old, his parents sent him to school but his ability to learn was questionable and he was taken away.

His father was a soldier who often served abroad with Kingsley's Regiment and was an assistant to the regimental surgeon. When he was discharged with dubious and suspicious qualifications, he managed to set himself up in practice 'in physick [sic] and surgery and passed himself off as a doctor for a livelihood'.

But the thought and imminent proximity of death brought Porson 'more happiness' after he was condemned to die than at any time during what he described as his 'evil courses'.

He did not boast or seem inordinately proud of his life of crime because he must have sensed somewhere along the way that he would not achieve a natural end to his existence. He moved back to some normality in his dealings with others after his mother 'was much concerned to see me in such a condition'.

Porson's mother had a stand at fairs and markets where she sold candied confectionery and he helped out. He then joined forces with a man who travelled the country selling pots, which were carried on horses. But he ran away and reached the town of Snaith in Yorkshire, where by chance he opened the gate to a house for a man and begged money from him. The man turned out to be his father who 'was exceedingly shocked at my situation'.

'He gave me a shilling and ordered me to come to his inn, he being on his way to attend patients at a distance from home. When I arrived at the inn, he ordered some cloaths [sic] for me, being ashamed to own me in the garb I was in. My mother came also to the same inn, and was very much concerned to se me in such a condition. I now determined to settle at home, and to assist my parents, which resolution I kept for some time. Going from one market to another, I soon got acquainted with graceless and abandoned companions, and we began our trade by picking the pockets of persons in fairs and markets of handkerchiefs etc. '

It was the start to a persistent and unstoppable life of crime, which, without any form of violence, was to lead Porson to his final court appearance and the death sentence. But this is going too far ahead because in the meantime he became very adept and accomplished at his criminal activities.

'These villainies led me on to the commission of graver crimes and by practice I soon became adept in the art of pocket-picking', he said. He joined forces with a man and between them they stole a silver tankard and a cloak, but he was not prosecuted by the authorities who decided he was too young.

He was told to join the navy in the hope that he might learn something useful to benefit him over the coming years, but he refused and was labelled as a vagrant.

Porson continued helping himself to things that belonged to other people and shortly after picking one man's pocket and taking another silver tankard from a public house, decided that things had to change. He just missed getting caught and later said, 'I began to think of the danger I was in, and resolved to quit the manner of life I had been accustomed to; however, this good resolution was soon changed by some of my old acquaintances who, observing me at a market with some trifling things, rallied me on the poor livelihood I was then getting, and persuaded me to return to my evil courses.'

By now he was in his late teens, easily led and unable to make decisions for himself. He was drunk or as he said 'in liquor' when he picked another man's pocket of a watch and was caught. He was committed to a house of correction in Manchester and later convicted when he appeared at the local quarter sessions. The judge ordered that he be 'publicly whipt [sic] twice and imprison'd one month'.

He became an accomplished pickpocket and on his release from prison wasted no time in getting back to his old habits. At a fair in Leek not far from Derby he helped himself to 12 guineas from a stranger's pocket. Porson seemed proud of the skills he had and continued, undeterred, at a gathering pace. 'At the last May fair at Ashbourne (in Derbyshire) I got about four guineas by this iniquitous practice', he said.

And so he went on, committing offences in Sheffield, Wakefield, Birmingham, Stockport and many other places where the pickings were good.

But like all criminals, Porson's luck eventually and predictably ran out. In his own words, 'the last crime that I was guilty of, and for which I now so justly suffer and ignominious death, was picking the pocket of Mr John Johnson at Ashbourne fair of a purse containing eight guineas and some silver. I met him in the street and jostled against him, and leaning upon him, to prevent myself as it were from falling, I drew out his purse.

But the old man, having been robbed much in the same manner at Ashbourne fair a twelve month, created suspicion in his mind, and clapping his hand to his thigh, missed his purse, and immediately pursued me; finding myself awkwardly situated; I, in defending myself against the old man, took an opportunity of flipping the purse, with its contents into his pocket; but being observed by a person, he came in as evidence against me on my, trial and I was accordingly capitally convicted.'

Porson was resigned to his fate and accepted the death sentence without question. On the day he was hung, a local scribe wrote of him, 'this unhappy man, though young in years, appears to be old in crimes. He has been concerned with, or known a great many of the rogues and thieves who travel the country from fair to fair, and town to town to rob and plunder the unwary.'

The judge asked if Porson had anyone who could give a character reference for him, but he said they were all were in London. The judge was urged to spare Porson's life but refused and said, 'as he had come from the metropolis with the avowed design of robbing and plundering the country, he should die'. The judge added that he was 'determined to punish all in similar circumstances' that came in his way.

Fortunately, attitudes towards crime have changed over the centuries; otherwise half of today's population would be waiting to be executed. But, at the same time, people are committing a growing number of murders and offences of such shocking and gratuitous violence that the punishment does not seem to fit the crime.

Details are published in newspapers every day where judges have passed lenient sentences or cannot be tougher because their hands are tied by laws passed in Parliament.

The scribe who penned details of the behaviour of young Porson as he waited for death to turn up, said 'he seemed quite resigned to his fate and said he had more happiness after he was condemned, than at any time during his evil courses'.

Monday 9 April 1787 was Porson's last day. He was released from his leg irons and spent time quietly talking to the Revd Mr Henry, the prison chaplain who regularly took the last walk with condemned men and women. Porson was put into a cart – most likely with his coffin beside him – and was taken past a vast crowd of onlookers to his place of execution.

When they arrived at the hanging tree, the executioner put the noose around Porson's neck and covered his head with a white hood. Not being one to waste time, Billington the hangman stood to one side, pulled the lever and Porson dropped until the rope halted his descent and a distinct crack could be heard as his neck broke. Soon after, his body was taken down and he was buried in the grounds of the nearby St Peter's church.

15

DERBYSHIRE'S UNSOLVED MURDERS

There aren't many unsolved murders in Derbyshire, but sadly that is no consolation to the relatives of the victims or detectives who tried hard to bring to justice those who had violently taken the lives of other people.

The police had their suspects in some cases and charged others who were acquitted after a trial.

It was two days after Christmas 1966 when fifteen-year-old Mavis Hudson lost her life when she was strangled in a derelict building in Chesterfield town centre. Several people were arrested. No one was ever charged and the person suspected of killing the teenager is now dead.

Nearly four years later, on 18 October 1970, Barbara Mayo, aged only twenty-four, was found strangled in woodland near Junction 29 of the M1. Several suspects were arrested but none were charged.

Just over a year later, John Hardy died after he was stabbed during an argument. He was murdered two weeks before Christmas on 13 December 1971. A man was charged but acquitted after a trial at Derby Assizes.

Wendy Sewell, aged thirty-two, was found beaten to death on 14 September 1973 in Bakewell cemetery. Stephen Downing was convicted of her murder but was released on appeal after serving twenty-seven years in prison. In 2003, the investigation was fully reviewed, which revealed no evidence of anyone else being involved.

In the winter of 1982, twenty-year-old Elaine Wakefield was strangled and her body was dumped on the High Edge raceway near Buxton. In was on a cold 27 February that she died. Detectives interviewed several suspects but no one was charged.

In a late-night shooting on the driveway of his house in Alvaston, Derby, forty-eight-year-old Brian Adams lost his life on 14 August 1990. Again, there were several suspects questioned by the police but none were charged.

Three years later, on 19 October 1993, a thirty-year-old woman was found strangled. She was identified as G. K. Sandhu. R. K. Sandhu, a man, was sent for trial charged with murder but was acquitted.

A sixty-three-year-old man was beaten to death at his home in Ilkeston three days before Christmas in 1996. A man was arrested and charged with the murder of Ronald Hull but the case against him was discontinued.

Michael Pritchard a fifty-four-year-old delivery driver was run over by offenders who stole his van at Kirk Langley, near Derby, on 14 November 1997. Police arrested several suspects but no one was charged.

Several people beat local vagrant sixty-three-year-old William Cox to death in Derby city centre on July 1999. There were several suspects but again no one was ever charged.

In December 2003, one of two vulnerable brothers died when arsonists set fire to a flat they shared in Mackworth, Derby. Kenneth Broughton, aged twenty-four, died but his brother survived. Several people were questioned and two were charged with murder but they were acquitted by a jury.

THE LIFE AND EXECUTION OF
THOMAS HOPKINSON, jun.

For Highway Robbery.

Even the highway robber felt the full force of the law...

The Life, Trial, Character, and Behaviour,

JAMES WILLIAMS,
Otherwise GREEN, otherwise HOLMES,

Who was executed on Derby Gallows, Thursday the 28th of March, 1782, for HORSE STEALING.

...and horse thieves did not fare any better.